THE BEAUTIFUL FLOWER IS THE WORLD

JERRY HSU

First published in the United States of America in 2019
by Anthology Editions, LLC

87 Guernsey Street
Brooklyn, NY 11222

anthologyeditions.com

Editor: Johan Kugelberg

Design: Bryan Cipolla

First Edition
ARC 065
Printed in China

ISBN: 978-1-944860-22-6
Library of Congress Control Number: 2018961642

THE BEAUTIFUL FLOWER
IS THE WORLD

JERRY HSU

Not many fine-art photos are funny. Sometimes they're witty (yuck). Sometimes they're clever (puke). But actually being capable of inducing laughs? Not so much. Yet the work you'll see from Jerry Hsu in this book, while assuredly functioning as art, is also often hilarious.

Conversely, lots of fine-art photos are tragic, or, rather, they portray various forms of tragedy. Many-flavored heaviness is all over the medium, whether it's a moody landscape of urban blight or a forlorn portrait of a forlorn human. But Jerry's pictures are dialed in to a special and far more valuable bandwidth of calamity, an instinctual sort of pathos that feels like a tiny, poignant knife in the heart. It's the tragedy of small moments astutely observed.

Jerry seems eerily aware of the brutal jokes the universe offers us daily via human folly and coincidence, if we're vigilant enough to look for them. Check out the photo of a discarded kissing booth shoved into a garbage can. Or the photo—a longtime favorite of mine—in which a bookstore's signage poetically and, we hope unintentionally, reads "CHILDREN SAILING HOME." How evocative is that? Or, of course, for simple guffaws, the cat on the trampoline. We live in a world that's rife with these sorts of visual puns, but few people are as masterful as Jerry is at spotting them and then making art from them.

There's another species of the tragicomic[2] in Jerry's work. It's a kind of touching and heartwarming squalor. Look at his picture of a grimly shrink-wrapped cheeseburger. I see this thing and, yeah, I laugh. But I also feel a twinge of sadness and a love for all humanity. I think of the wretched fuckers who are going to unwrap that cheeseburger—and all the world's similar cheeseburgers—and eat it. To me this one cheeseburger, in Jerry's rendering of it, contains the depth and impact of a great short story. The warmth, even the love, for piteousness that we find in a photo like this feels more British than American to me, akin to the work of someone like Martin Parr or (perhaps more in outlook than in actual look) that of the filmmaker Mike Leigh.

- - - - - - - - - - - - - - - - -
1. A.k.a. that happy mask/sad mask theater thing typically seen in high school drama departments and way too many tattoos.
2. Disclosure: I realized upon revising this introduction that I made a similar observation in an essay on my and Jerry's mutual friend Tim Barber's photos in 2011. I guess they just have similar ways of seeing the world. That's probably why they like each other. Anyway, self-plagiarism alert. Gotta lay off the weed.

As I think about it, I see that I break Jerry's photographic body of work down into four elemental properties: funny, tragic, beautiful, and trippy. I believe that all of Jerry's quintessential photos contain at least two of these properties (beautiful being a default characteristic that most of his photos possess). There are many that contain three of them. There are even more rarified four-element photos. See if you can spot any of these in the pages that follow.

A Hsu photo matrix could look like this:

FUNNY + TRIPPY:	BEAUTIFUL + TRIPPY:
The Lynchian dump truck with disturbingly expressive unhappy faces spray-painted onto its mud flaps	The Vermeer-ish portrait of Jerry's wife, Kat
TRIPPY + TRAGIC:	FUNNY + TRAGIC:
A pile of meat in a plastic tub—one hunk still bearing the eye of the unfortunate butchered creature	Man at a pharmacy counter with the ass of his jeans blown out

III. SMS&M

Jerry is one of my favorite photographers for the handling of found objects. There are easy layups, like church signs, vanity license plates, and misguided corporate slogans. But Jerry also takes lots of photos in thrift stores and at flea markets—goldmines for finding uncanny objects, but minefields for a photographer looking to make a worthwhile picture. And yet, where many fail, Jerry succeeds.

Adding to the found-object quality of much of this work is the fact that these are camera-phone photos. They have a sense of immediacy that a digital or snapshot camera can't offer. In our time, the phone is an auxiliary id, a gooey vault for our secrets, and Jerry uses its lens like an extra eye in the flow of his observations. To look at these pictures is to be fully on board Jerry's train of thought, deeply embedded in his perception of the world. To look at these pictures is to put the Hsu filter over your own eyes.

Jerry has said that he began using his phone to take pics as both a form of note-taking (which I believe is, for the artist, a direct dialogue between the superego and the id) and to text photos to friends as sort of one-line gags—in addition to capturing sentimental sights to send to the people he loves. In Jerry's case, these dispatches from the interior are vulnerable and revealing reflections of his self out there in the world. His friends who received photos in this book as text messages (a cohort I'm lucky to be a part of) got these things as little surprises in the course of their day, as chances to share Jerry's sight for a second and to feel an empathic connection to him. Now, in this volume, these photos have accumulated into a mass of moments that, taken as one, offers us a strategy with which to look at anything and everything. And it's true, god, ugh, the world really is like this. Beautiful and sad and so funny. Thanks for reminding us, Jerry.

Jesse Pearson

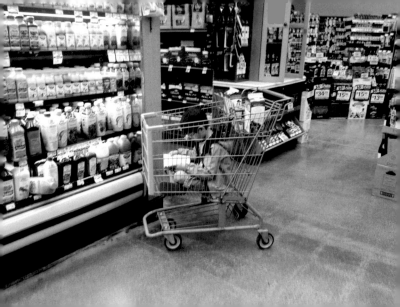

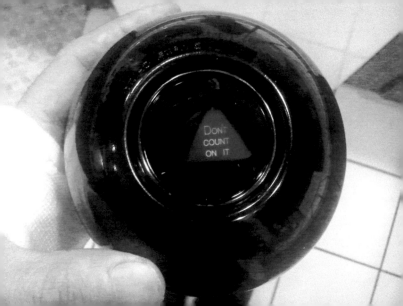

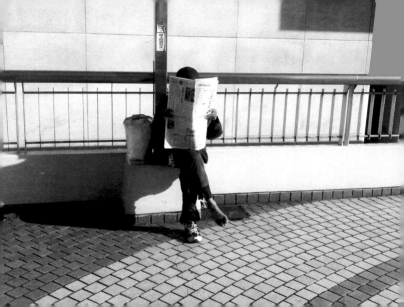

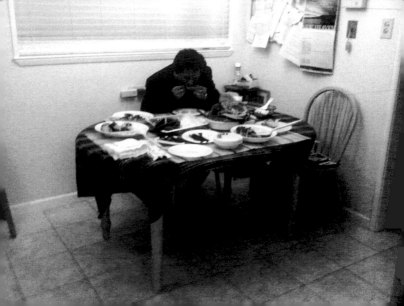

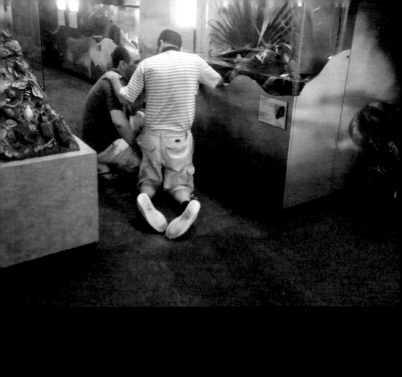

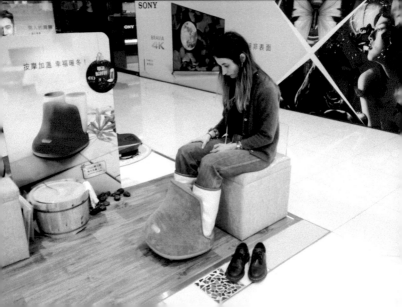

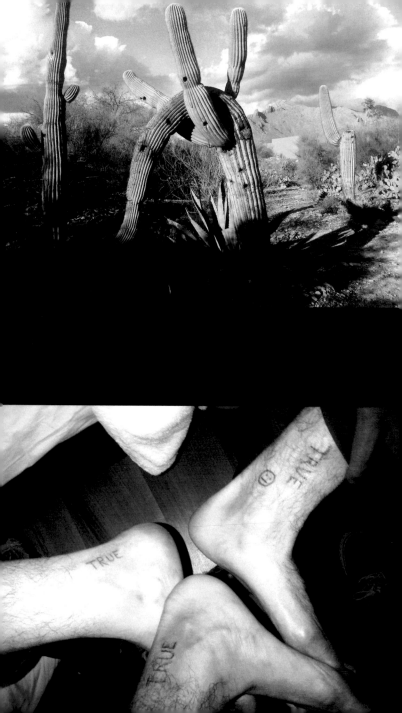

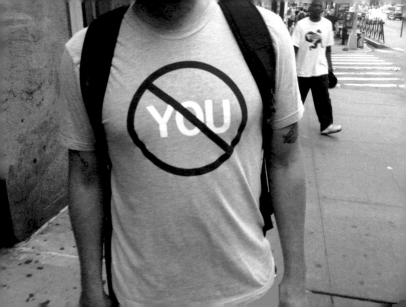

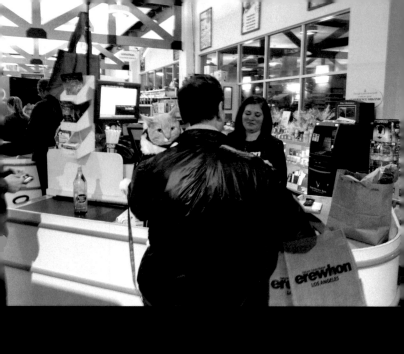
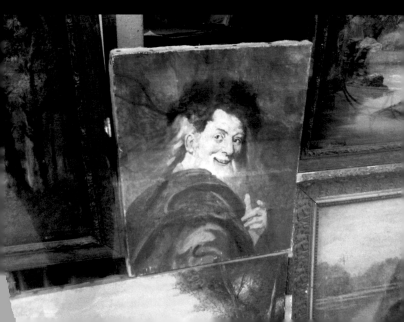

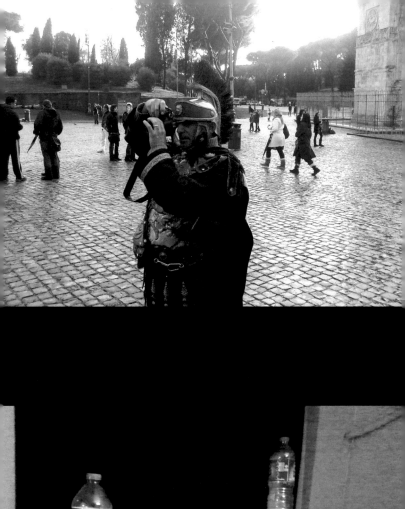

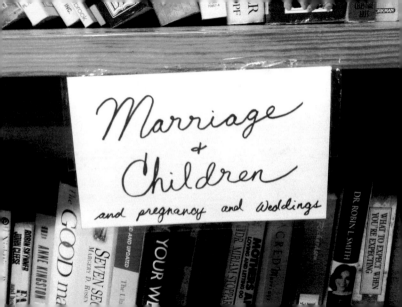

Marriage
+
Children
and pregnancy and Weddings

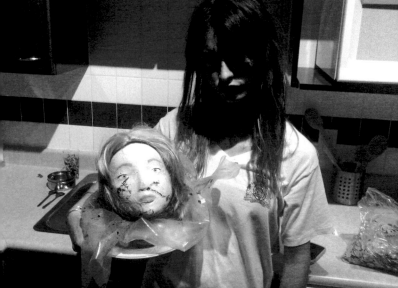

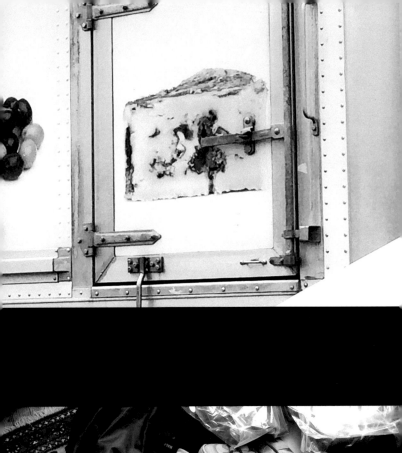
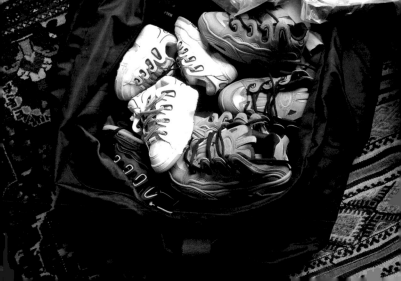

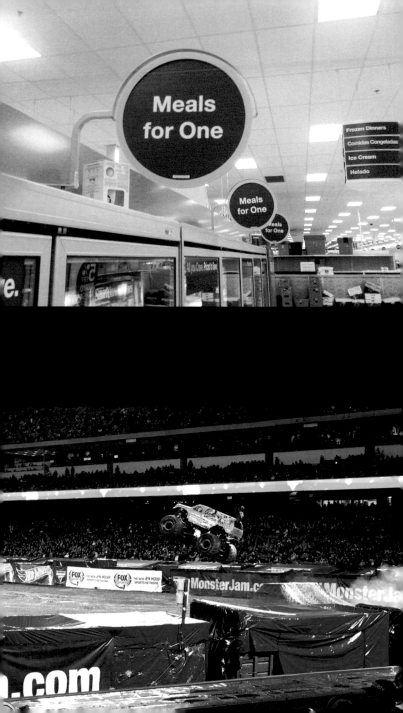

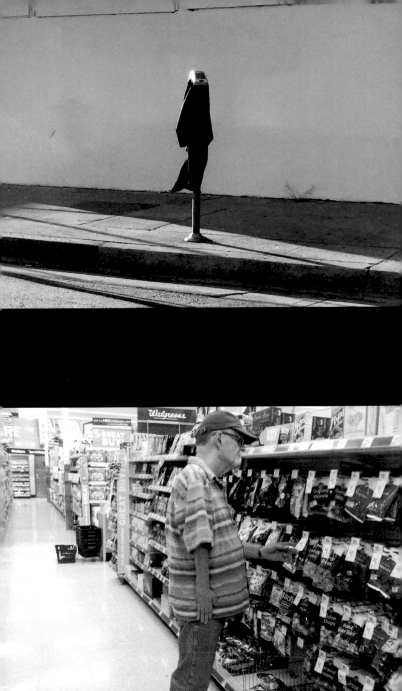

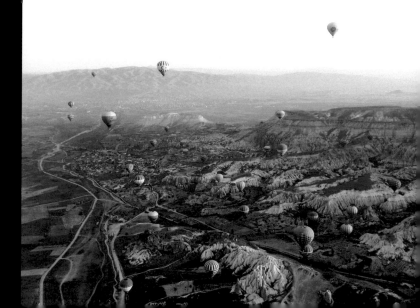

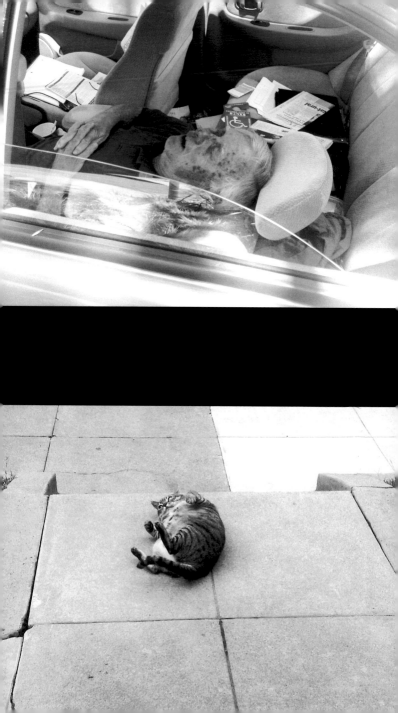

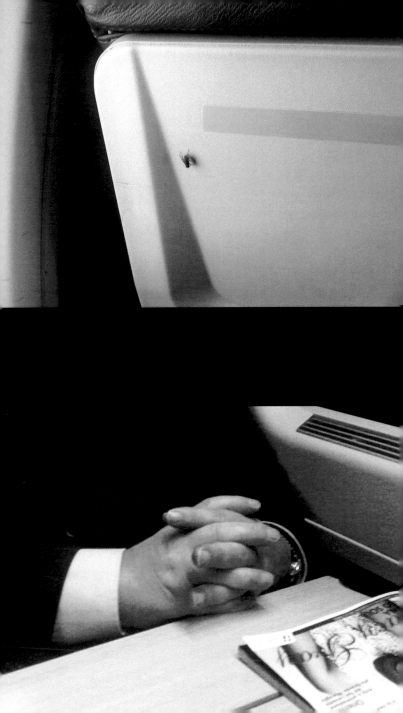

5:01

0:38

Skateboarding Fail

2 years ago
2,374,599 views
Because you watched
Jerry Hsu

s

d

The Byrd
Miles Hig

1 year ago
125,969 vi
Because y
Jimmy Buff

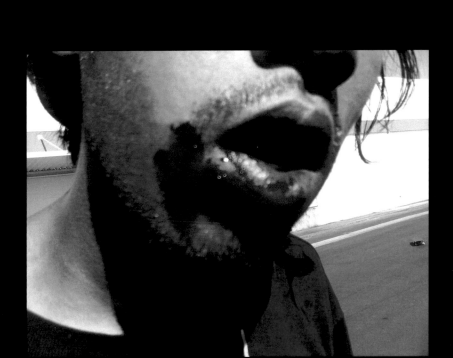

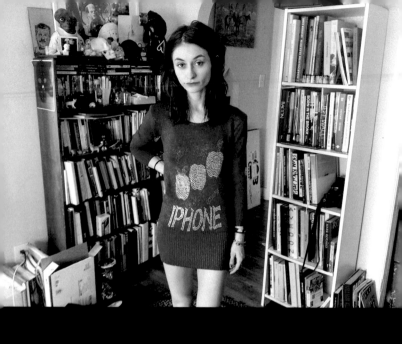

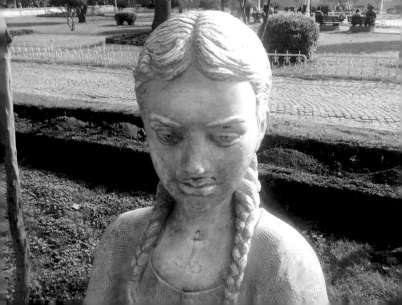

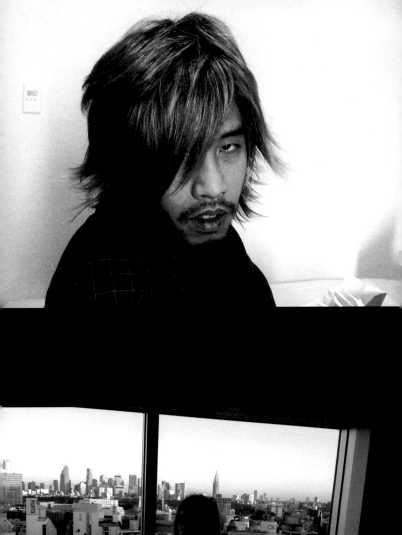
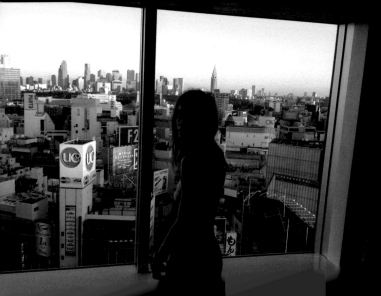

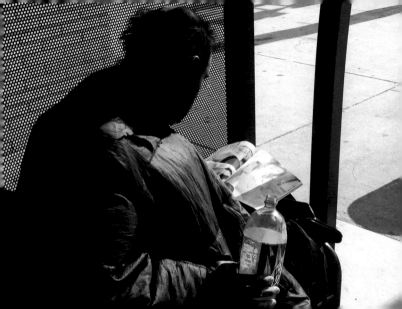

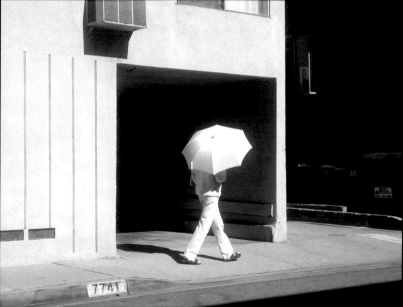

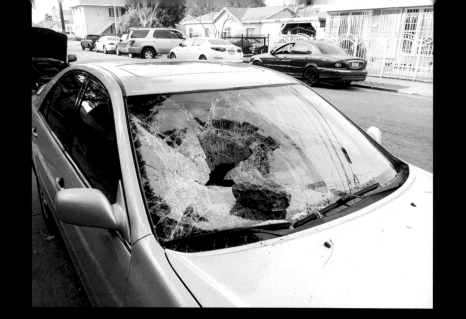

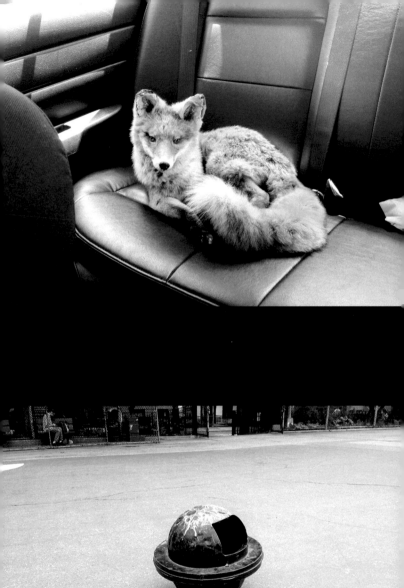
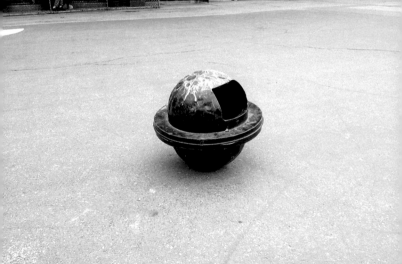

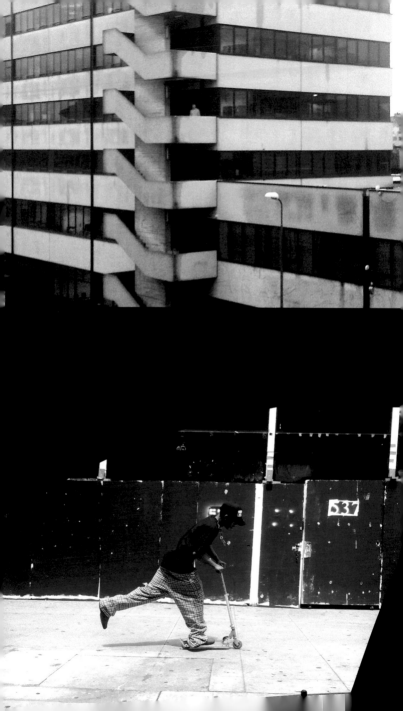

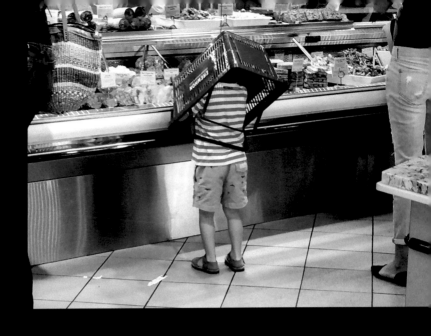

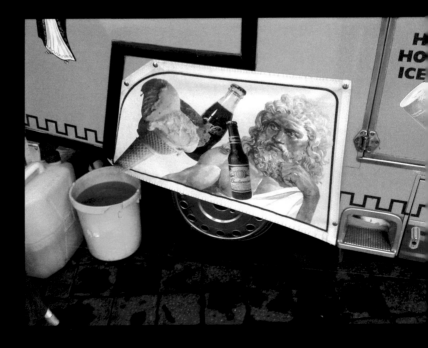

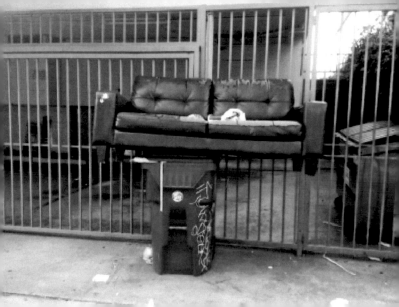

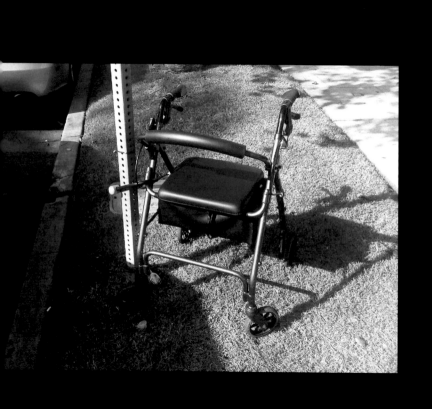

the Beautiful flower is the world l
is Love is be beautifid flower life
in the oioexsotrktnstst

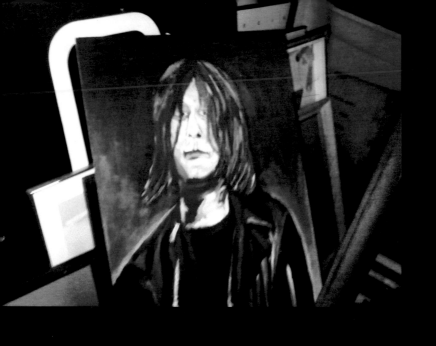

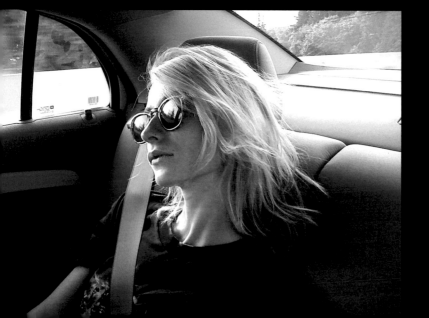

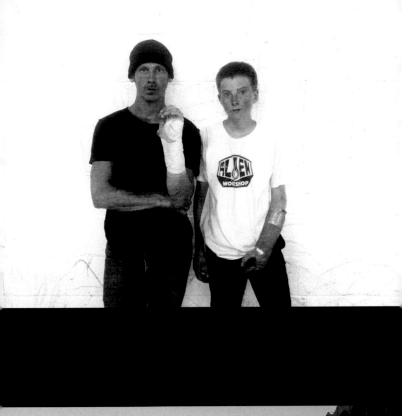

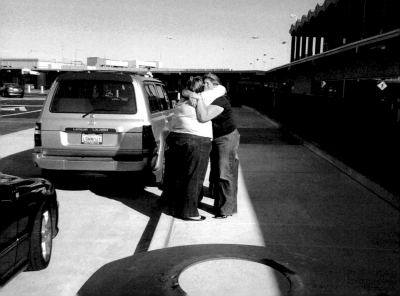

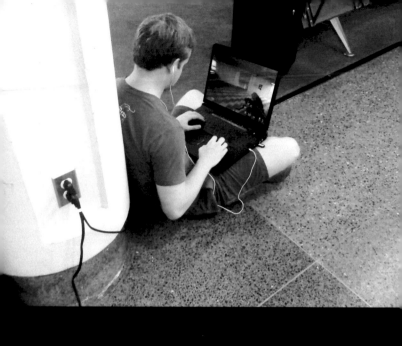
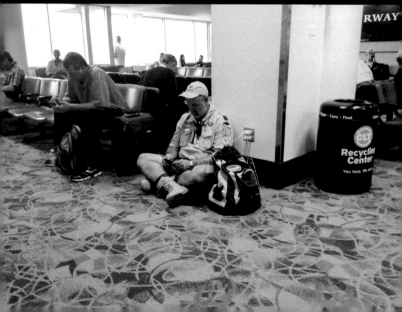

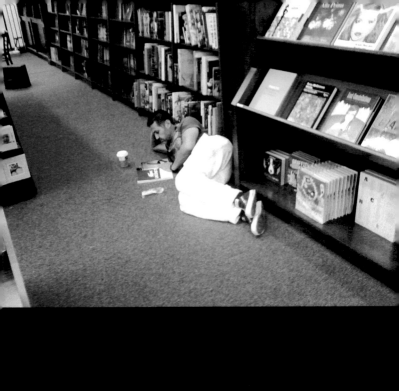

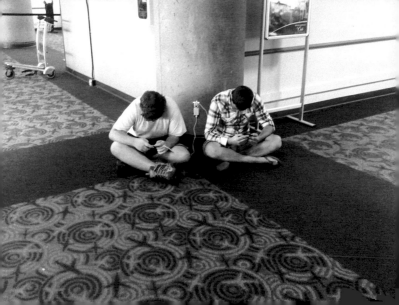

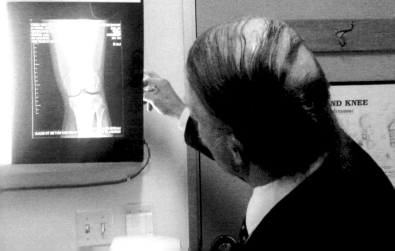

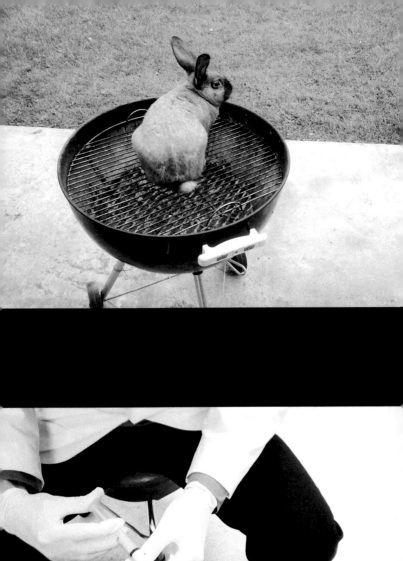
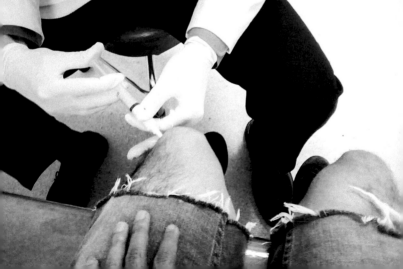

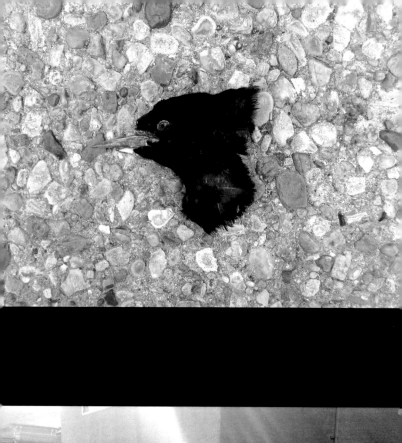

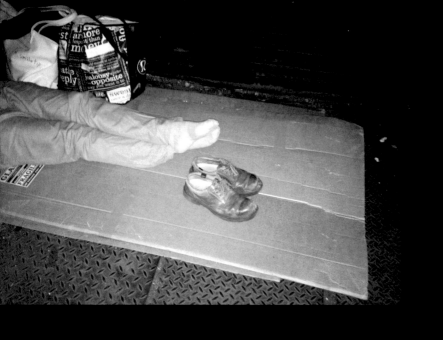

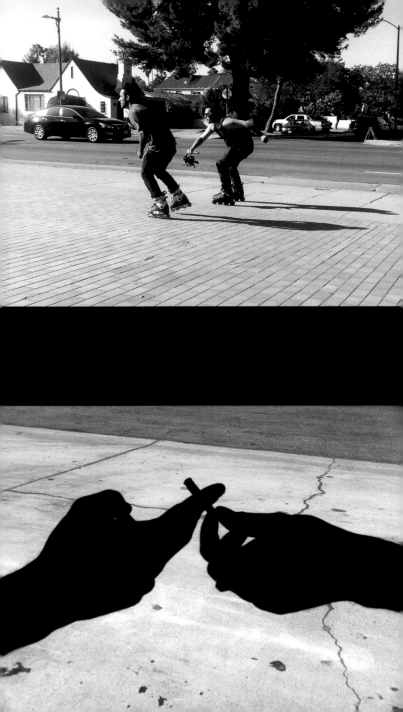

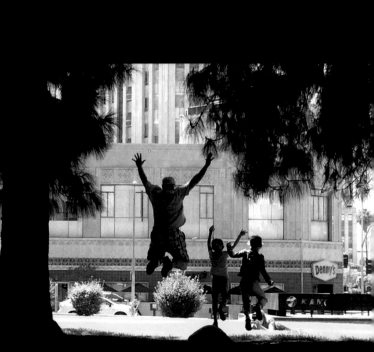

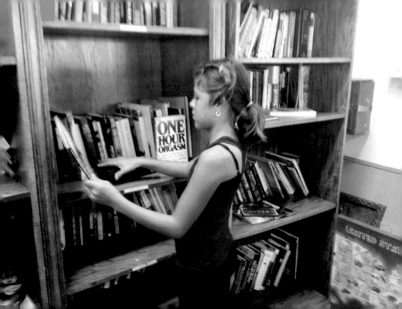

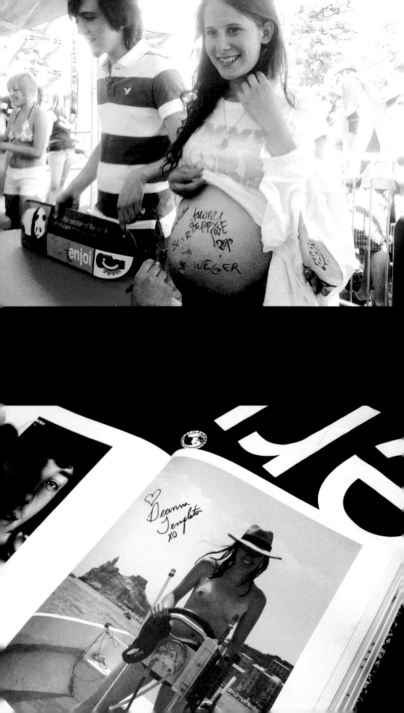

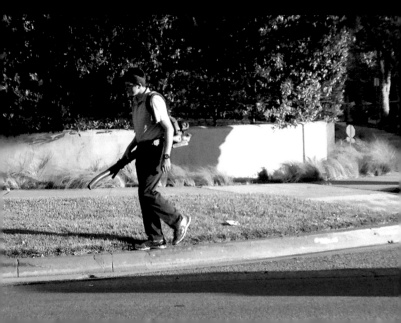

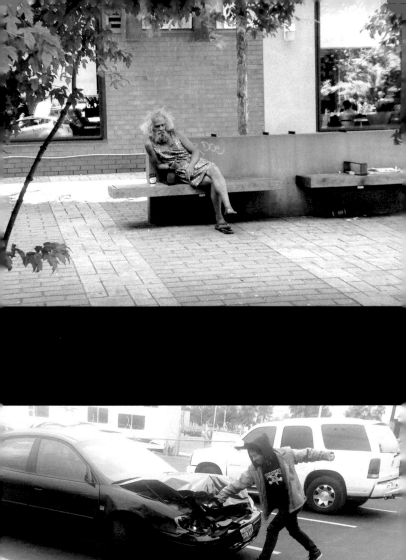
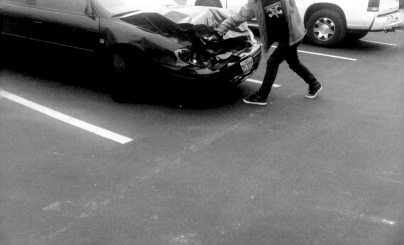

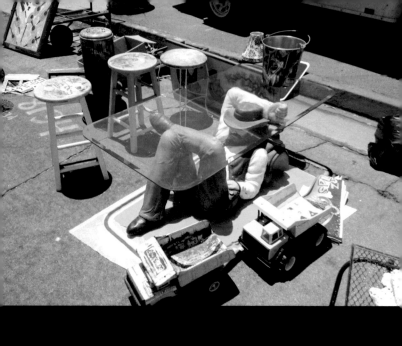
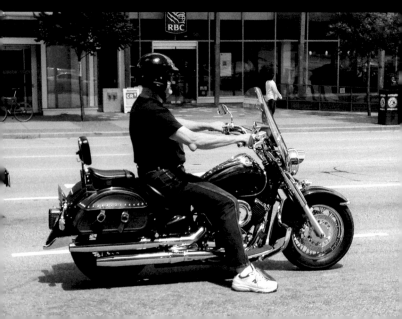

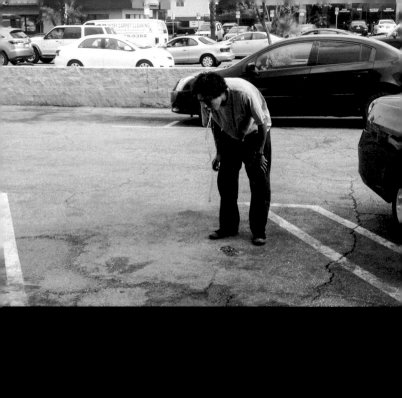

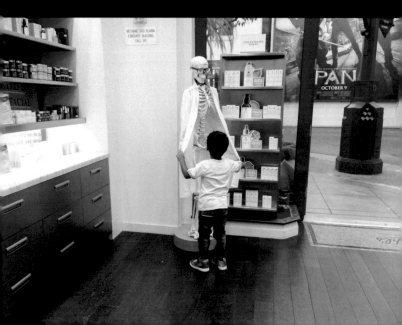

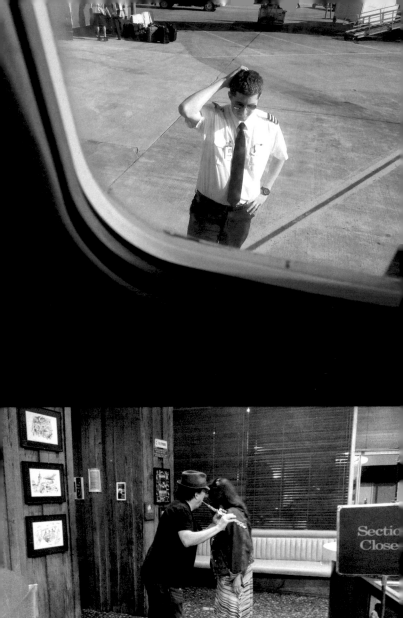
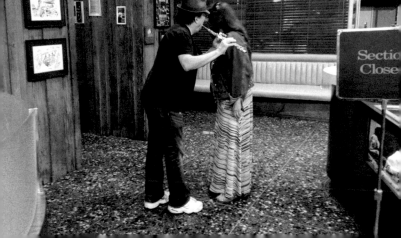

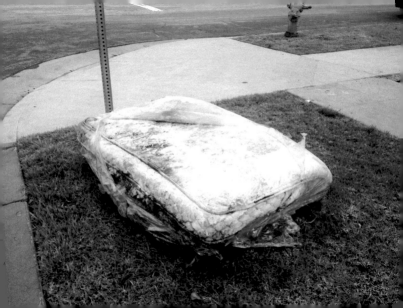

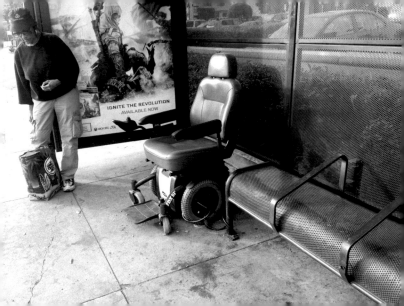

JERRY-
WE'RE OVER IT
SORRY

DIVORCIO RAPIDO

 LIQUORS

LOTTERY

MONEY ORDERS

ATM MACHINE

Modelo

Chelada

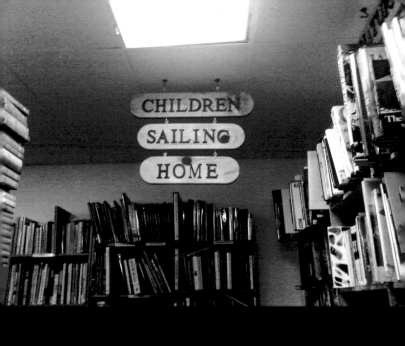

CHILDREN

SAILING

HOME

ROBOT

LIFE = CANCER

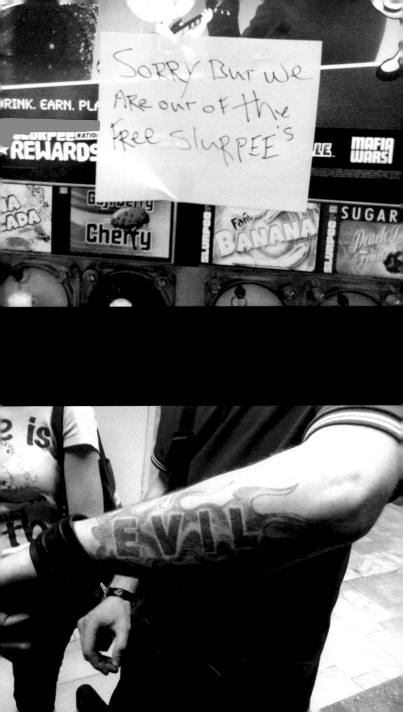

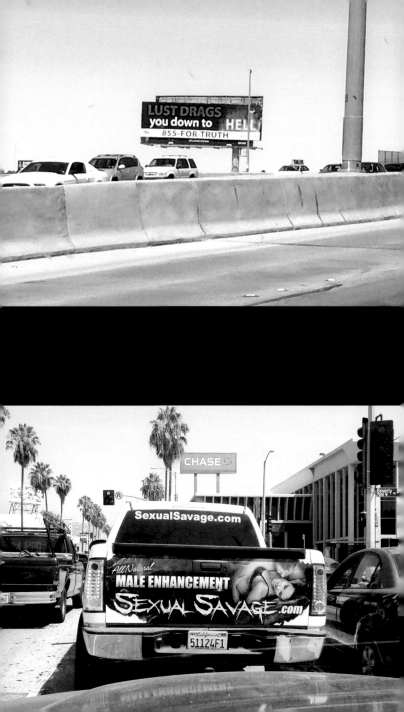

rom

Man wins lottery, leaves wife

2:04

The top v
2009

Biblically
Responsible:
-Investing
-Insurance
-Financial
Planning

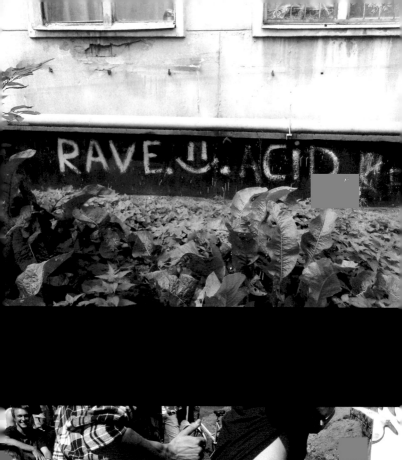
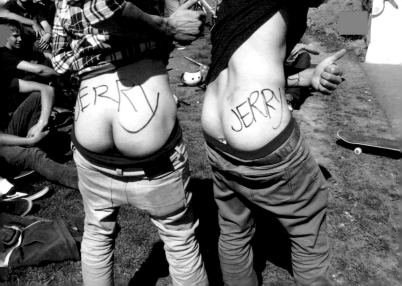

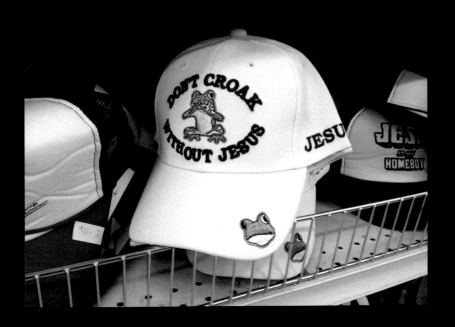

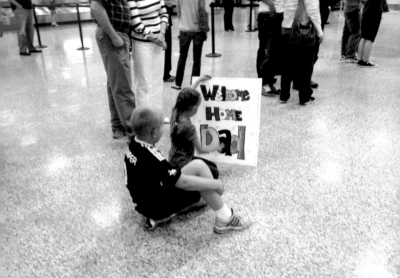

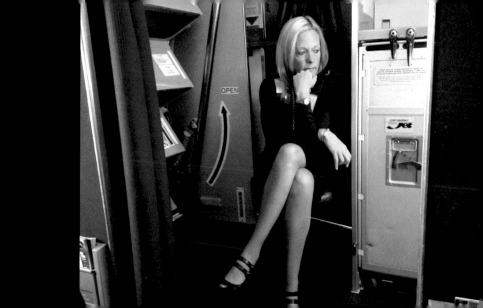

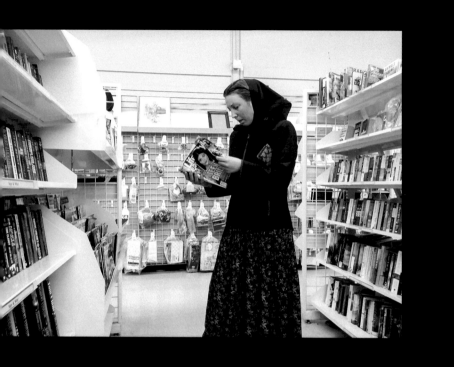

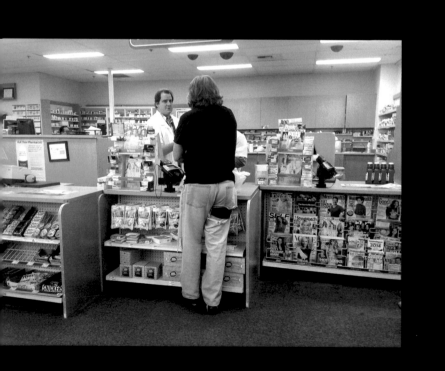

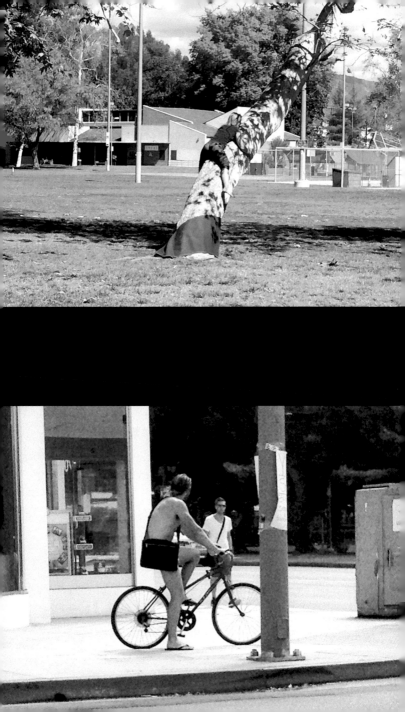

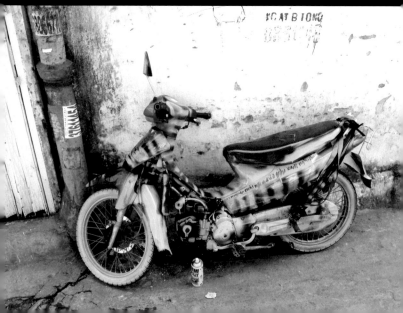

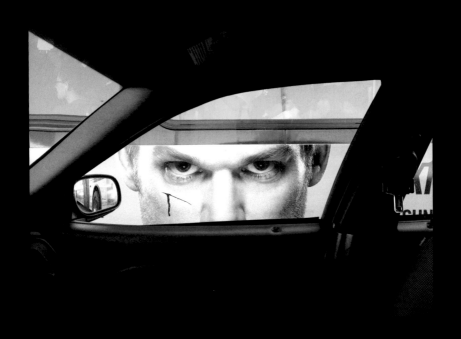

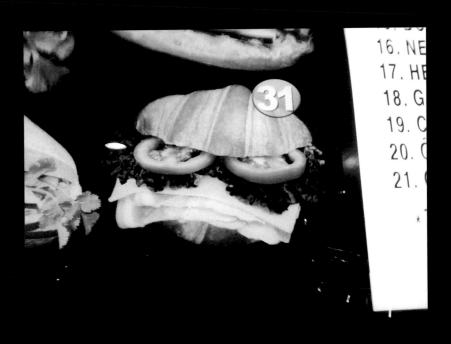

16. NE
17. HE
18. G
19. C
20. Ö
21. C

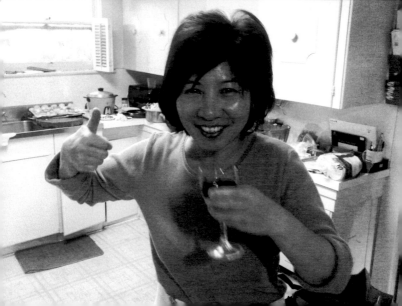

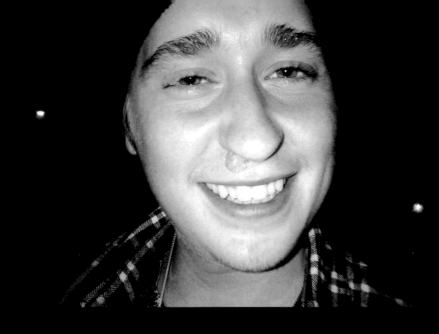
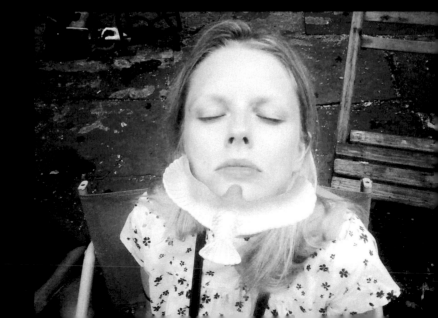

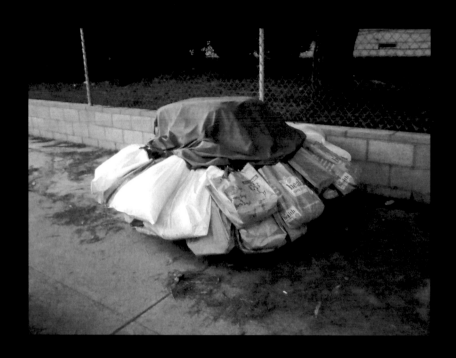

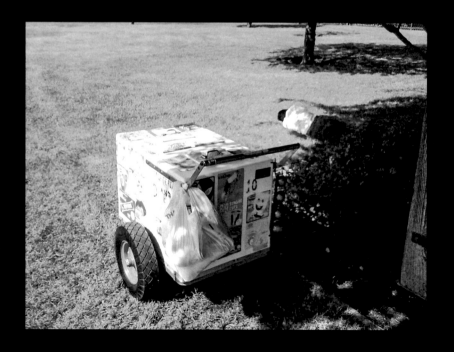

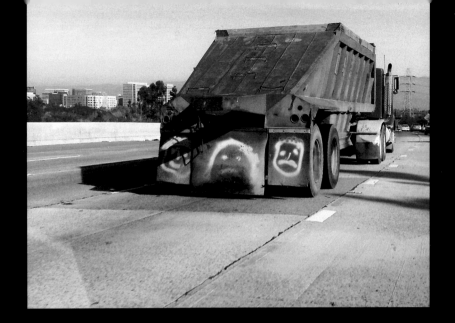

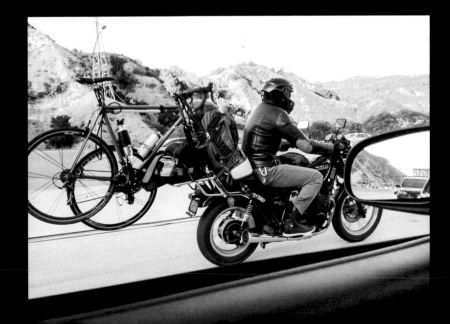

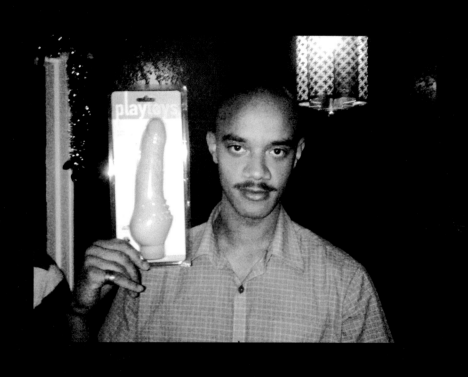

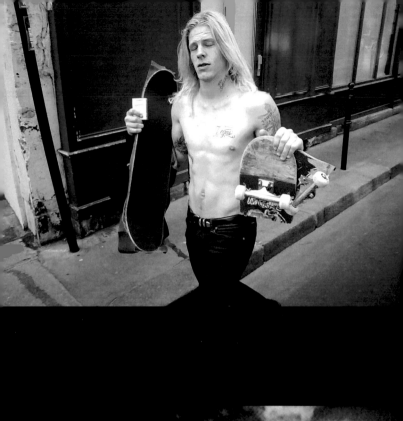

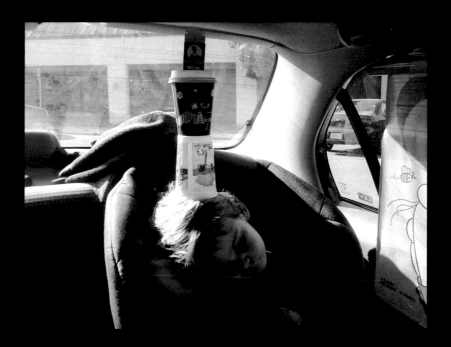

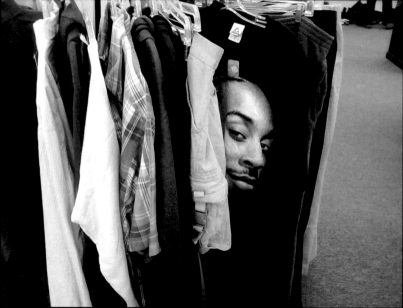

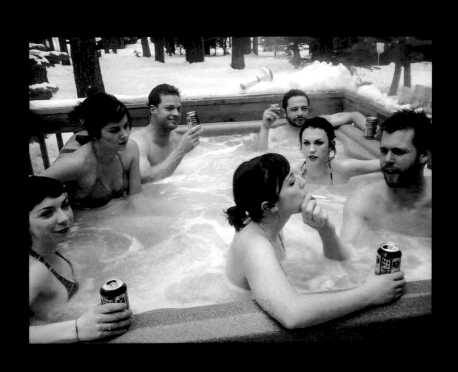

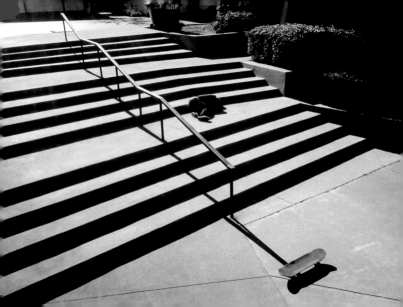

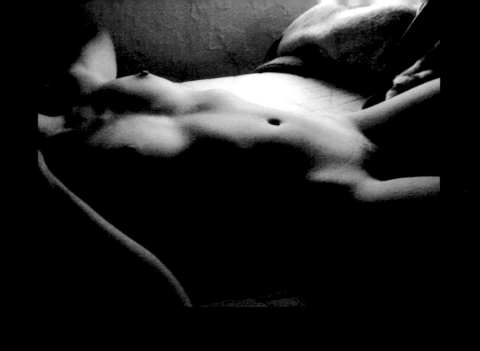

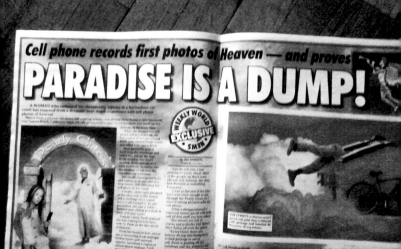

Cell phone records first photos of Heaven — and proves

PARADISE IS A DUMP!

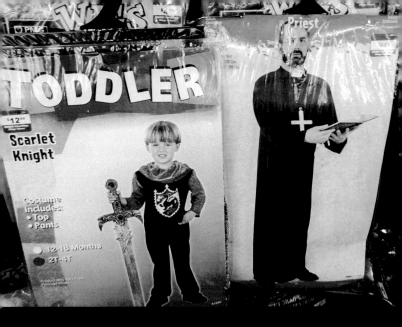

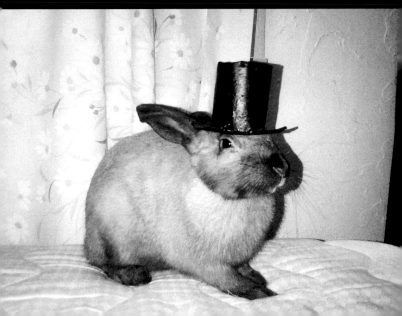

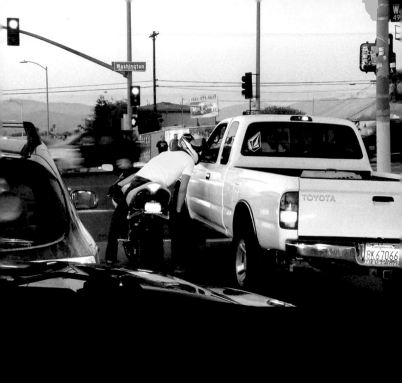
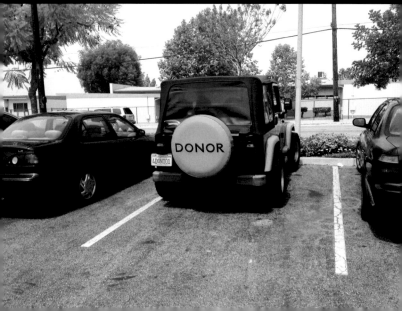

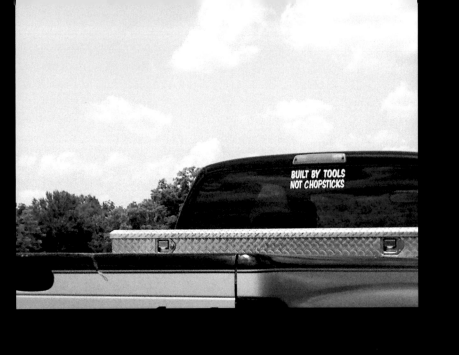

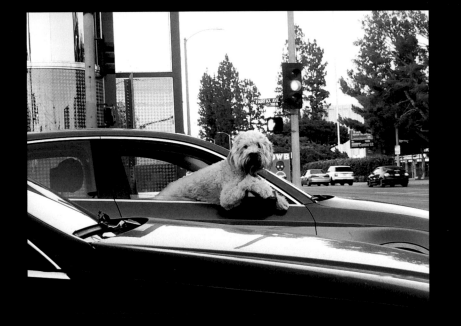

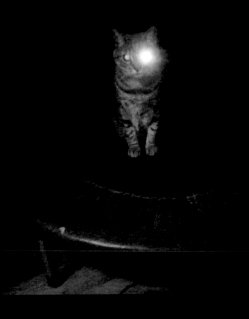

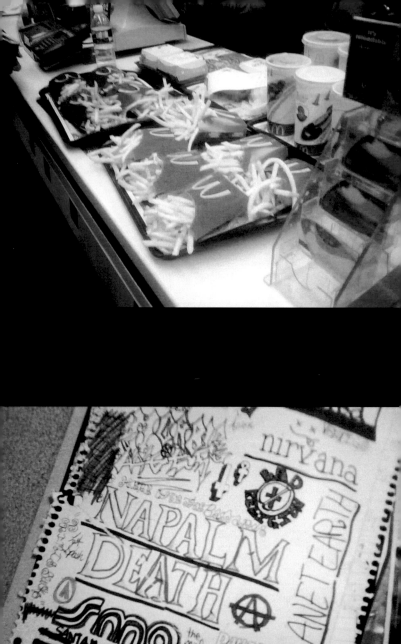

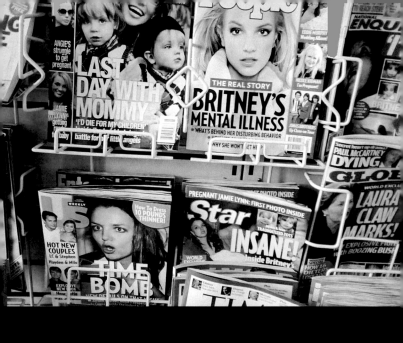

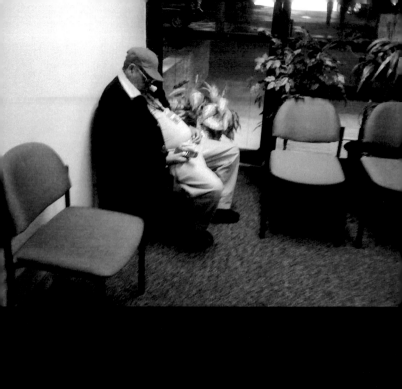

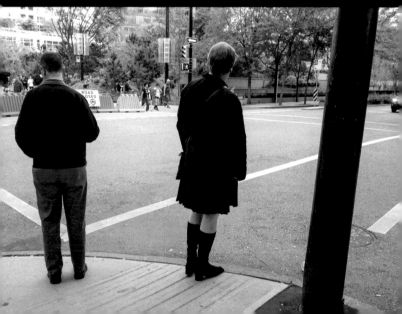

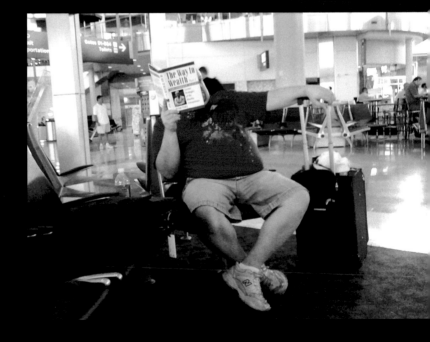

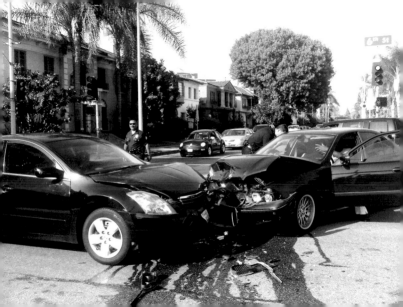

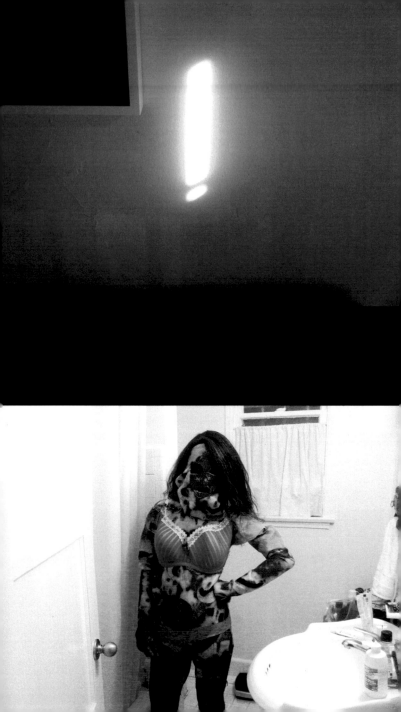

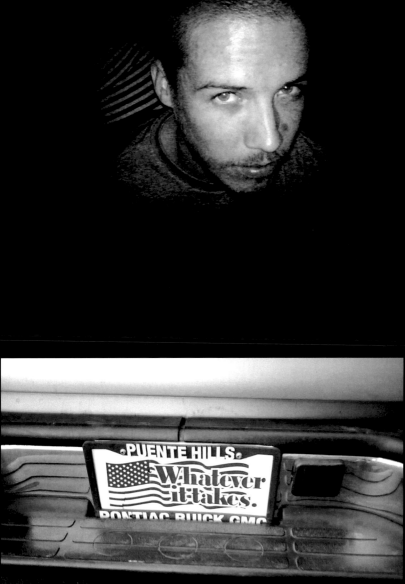

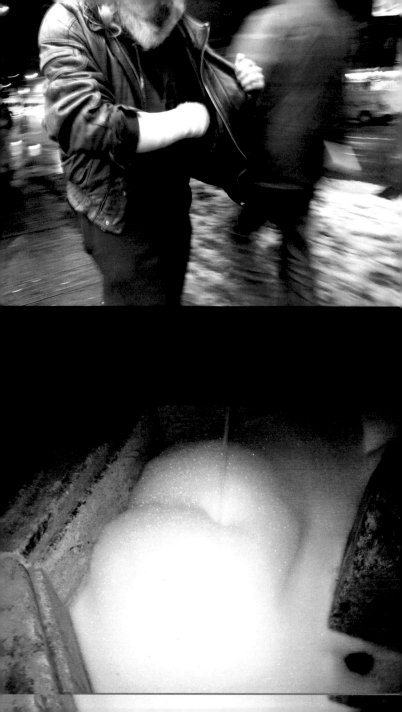

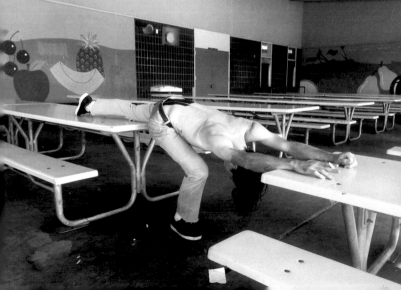

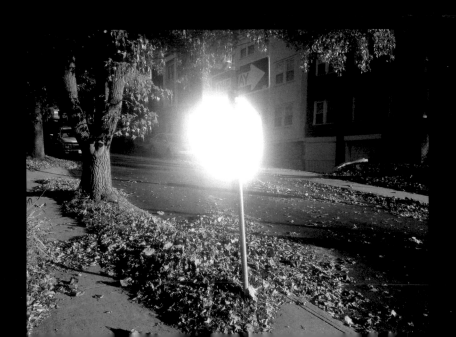

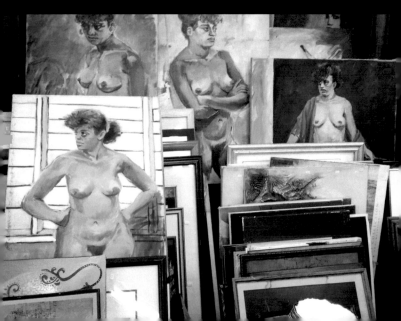

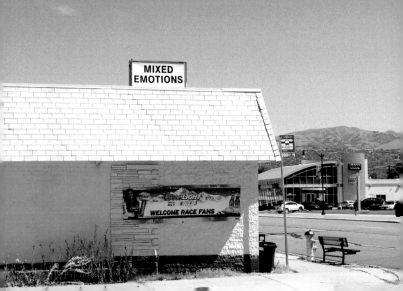

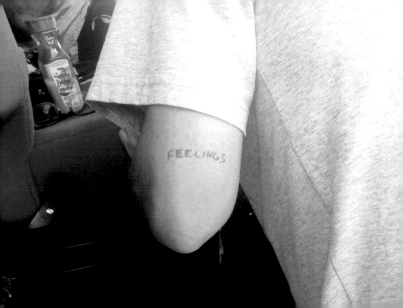

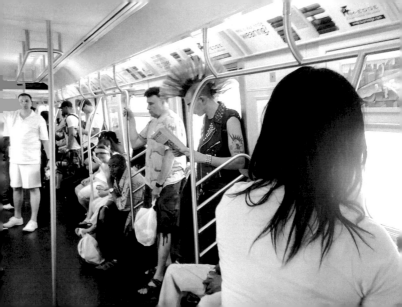

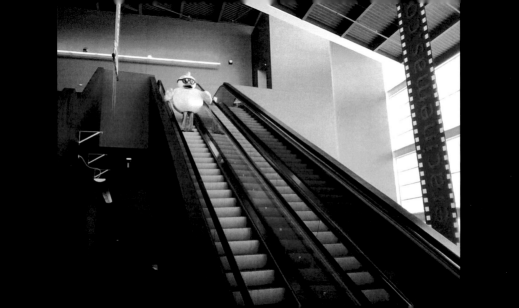

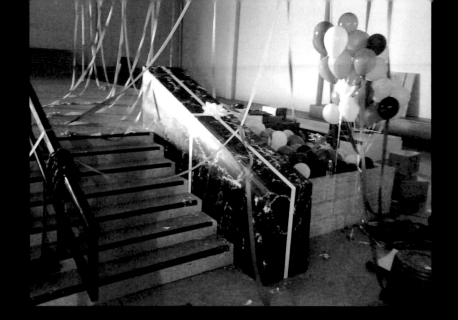

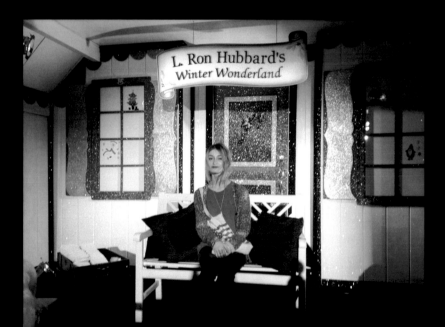

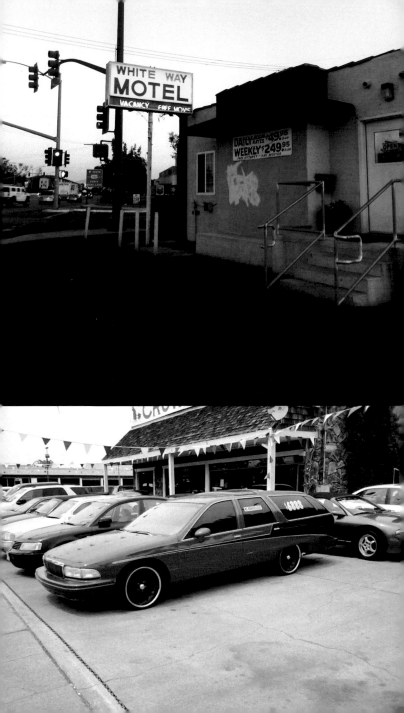

FIRST PRESBYTERIAN CHURCH

" PREGNANCY AND
POSSIBILTIES! "

SUNDAY WORSHIP
10:30 AM (408) 297-7212

VISIT OUR WEBSITE
www.fpcsj.org

FIRST PRESBYTERIAN CHURCH

" JESUS IS STILL
WEEPING "

SUNDAY WORSHIP
10:30 AM (408) 297-7212

VISIT OUR WEBSITE
www.fpcsj.org

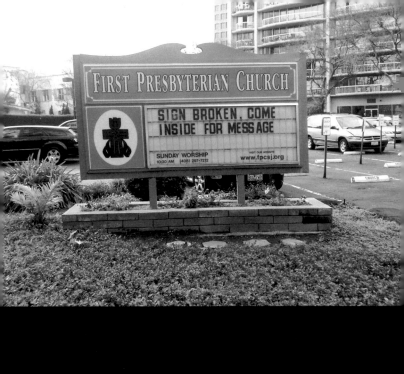

FIRST PRESBYTERIAN CHURCH

SIGN BROKEN, COME
INSIDE FOR MESSAGE

SUNDAY WORSHIP
10:30 AM (408) 297-7212

VISIT OUR WEBSITE
www.fpcsj.org

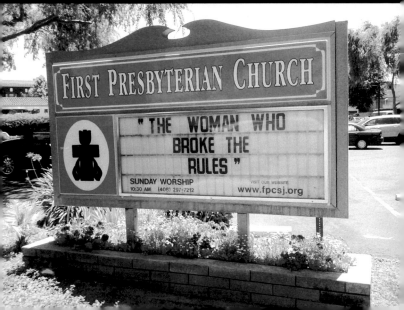

FIRST PRESBYTERIAN CHURCH

" THE WOMAN WHO
BROKE THE
RULES "

SUNDAY WORSHIP
10:30 AM (408) 297-7212

VISIT OUR WEBSITE
www.fpcsj.org

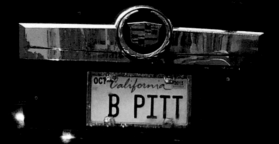

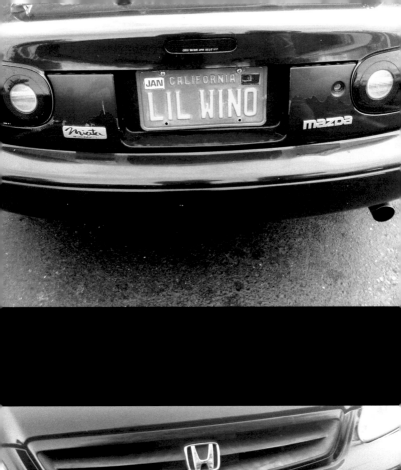
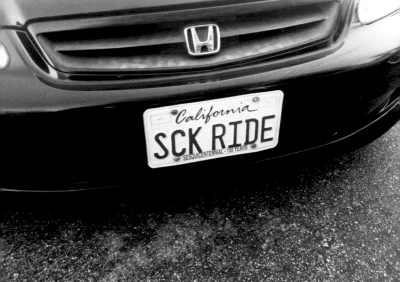

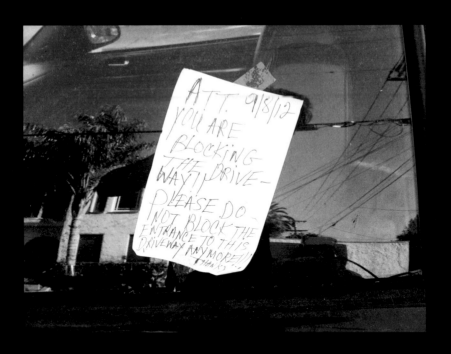

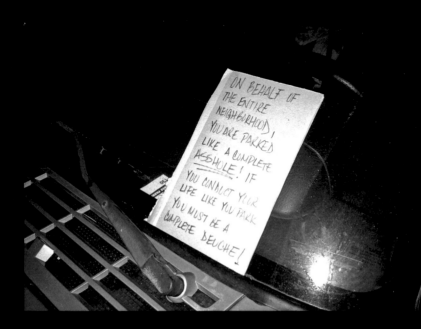

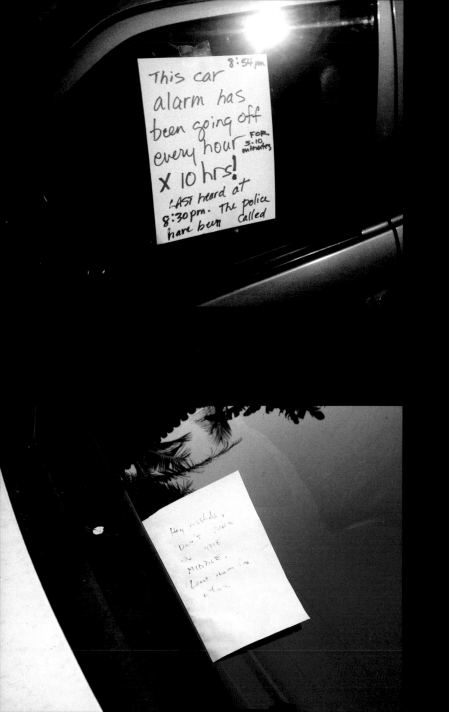

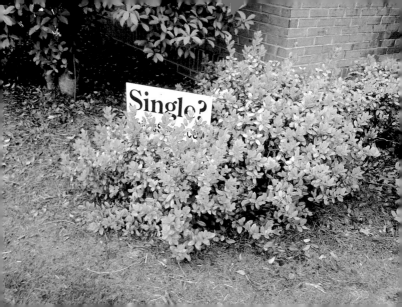

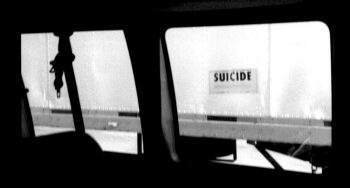

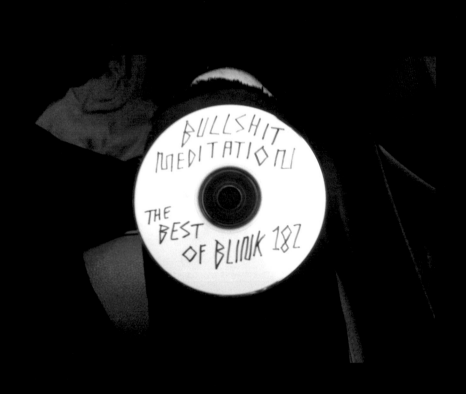

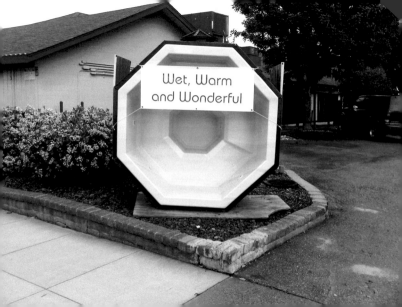

Wet, Warm
and Wonderful

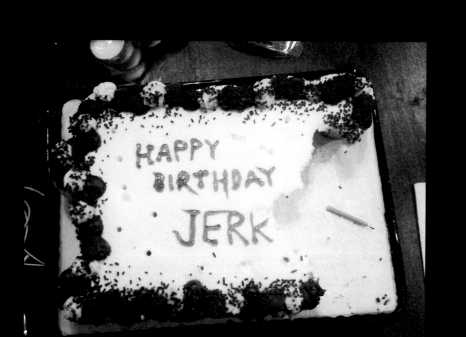

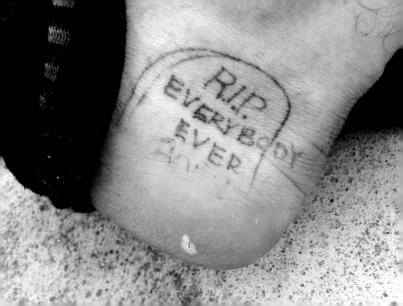

NUKE EM

Stuart Anderson's

BLACK ANGUS

STEAK SEAFOOD PRIME RIB

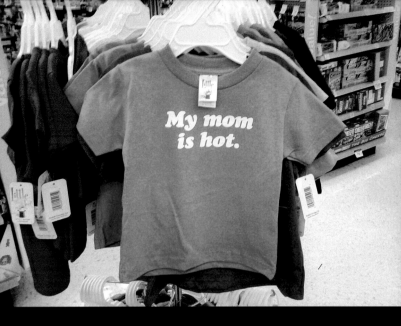

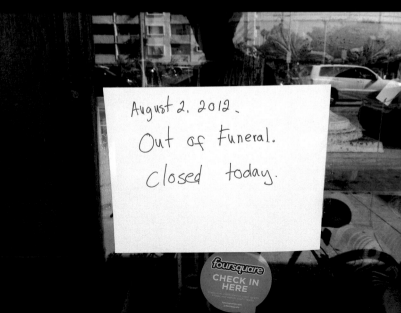

August 2, 2012.
Out of Funeral.
Closed today.

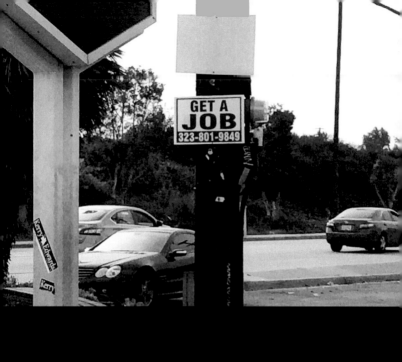

WHATEVER YOU DO, DO IT
ALL FOR THE GLORY OF GOD.
-- I COR 10:31

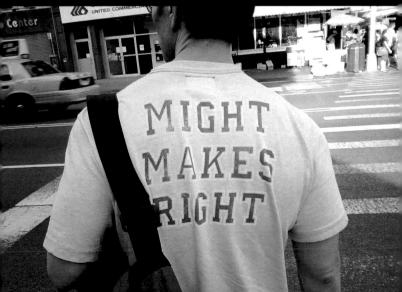

MIGHT
MAKES
RIGHT

WE SAY
MERRY CHRISTMAS

RESBYTERIAN CHURCH

THE IMPOSSIBLE DREAM

SUNDAY WORSHIP
10:30 AM (408) 297-7212

VISIT OUR WEBSITE
www.fpcsj.org

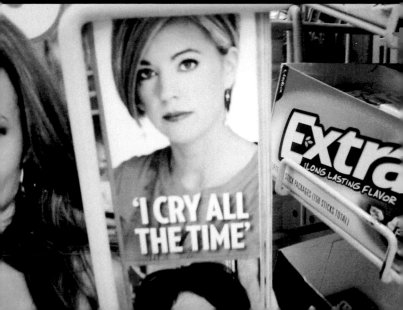

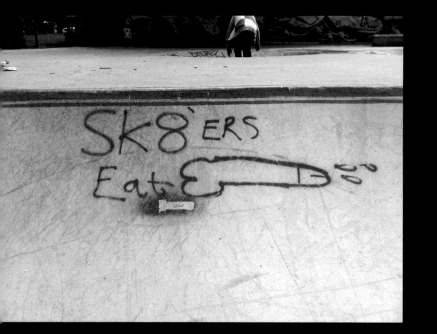

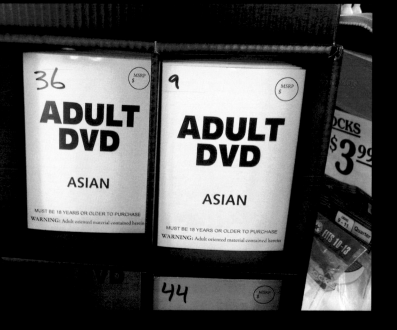

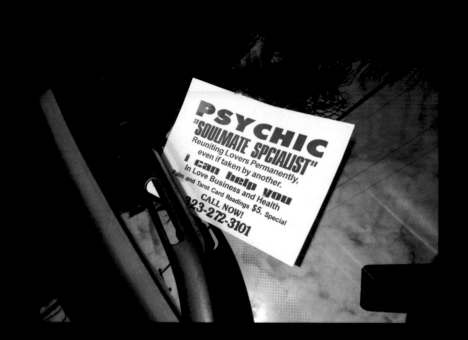

Been taken for
granted?
Imagine how
God feels.

THE GATE

Challenges

Braydon Szafranski

BAM

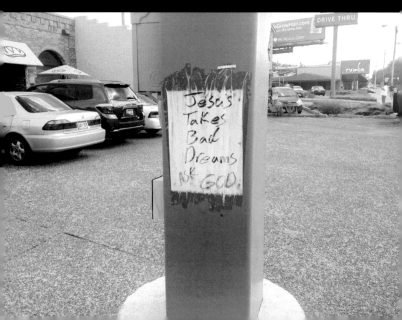

Jesus
Takes
Bad
Dreams
ASK GOD.

FUCK all
Parents

if you read
this your gonna dic

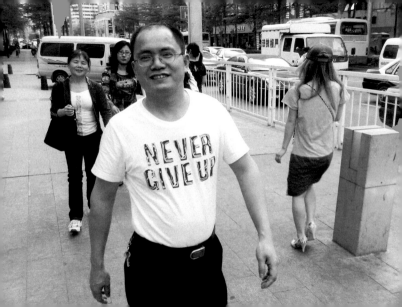

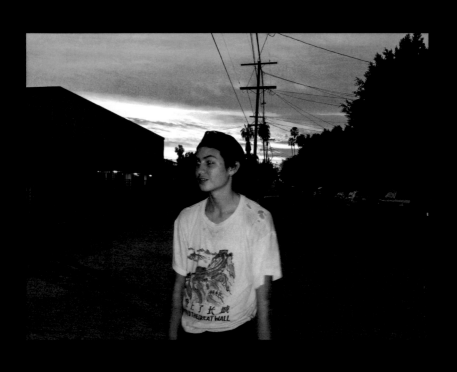

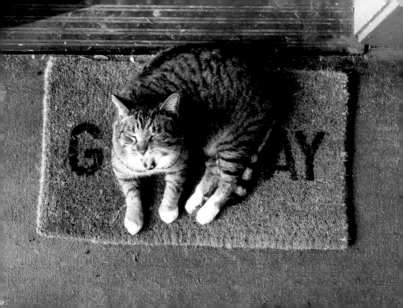

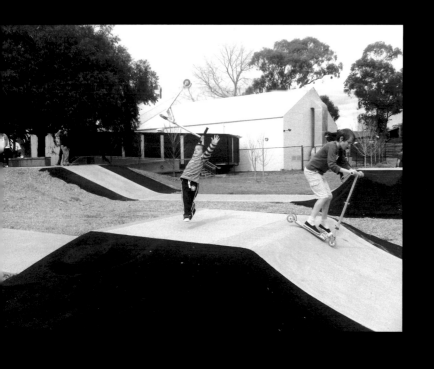
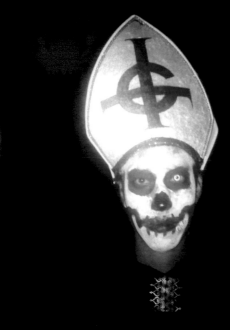

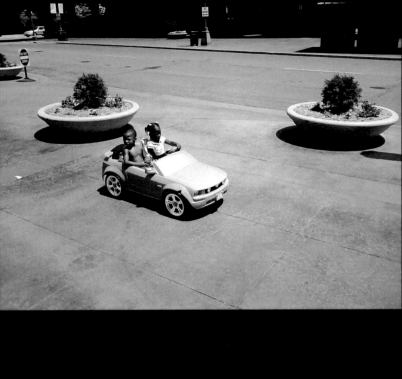

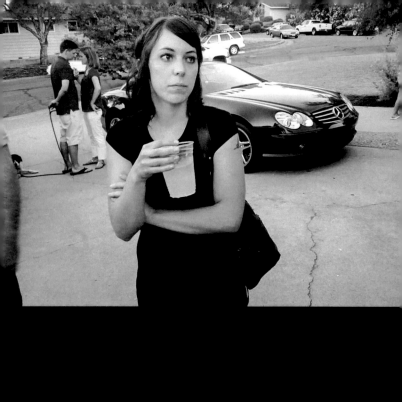

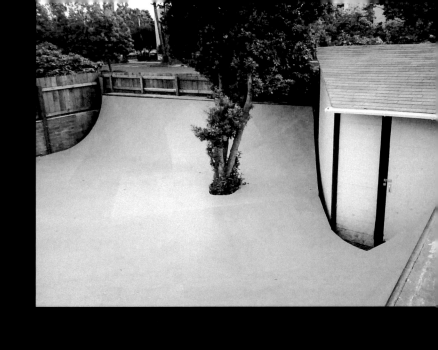

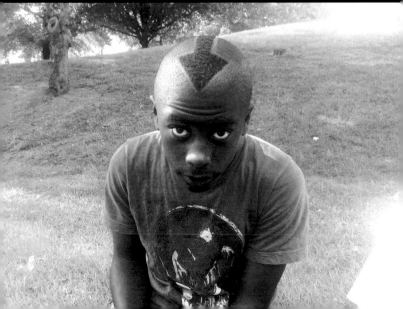

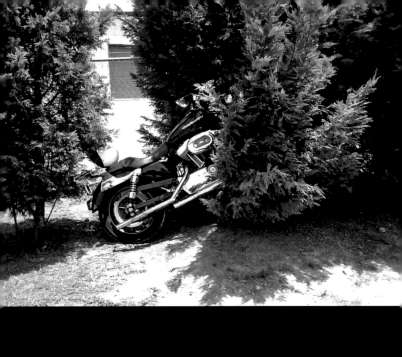
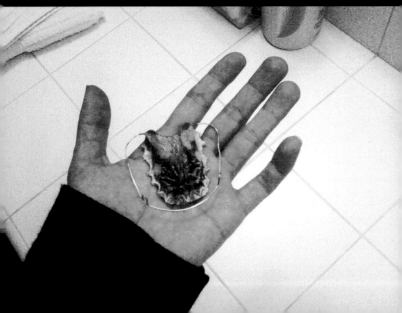

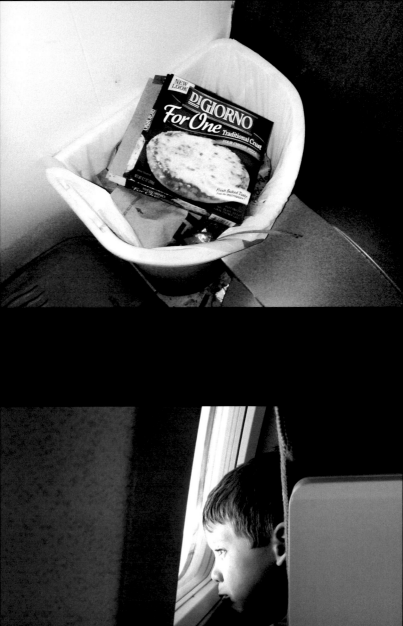

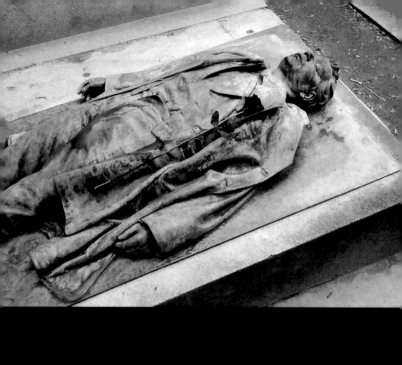
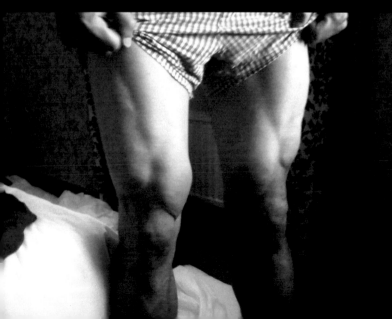

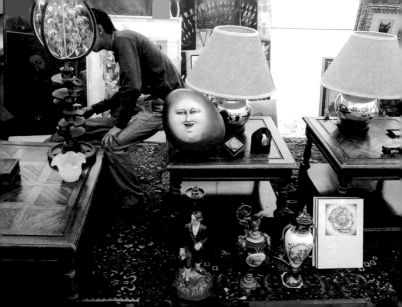

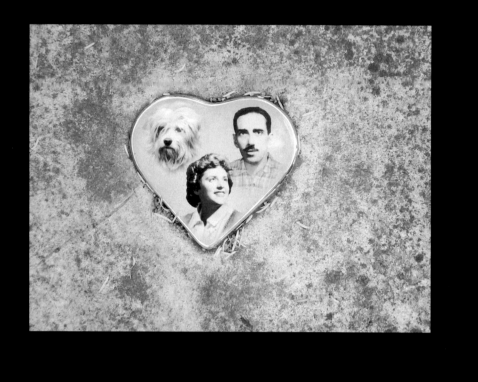
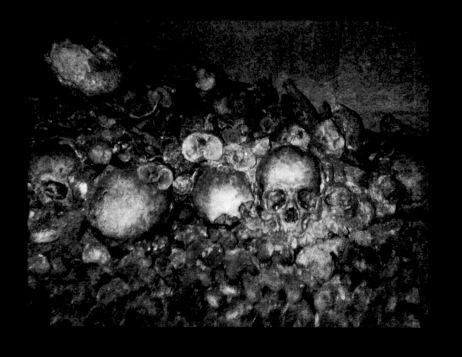

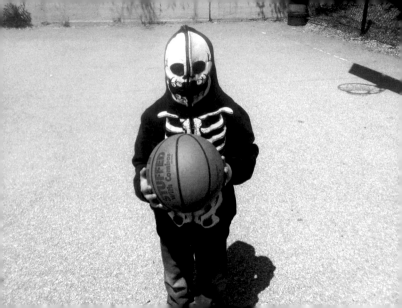

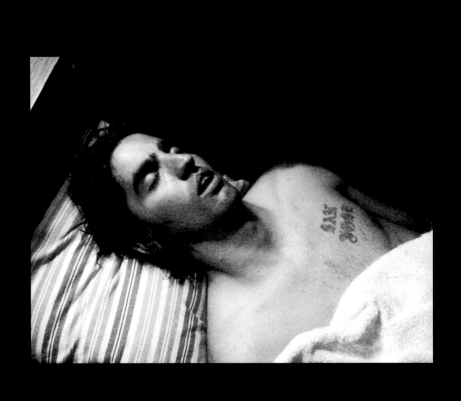

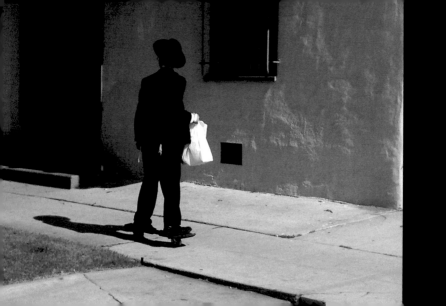

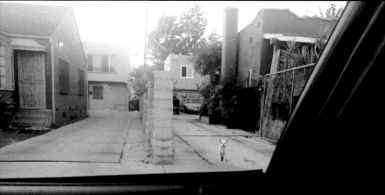

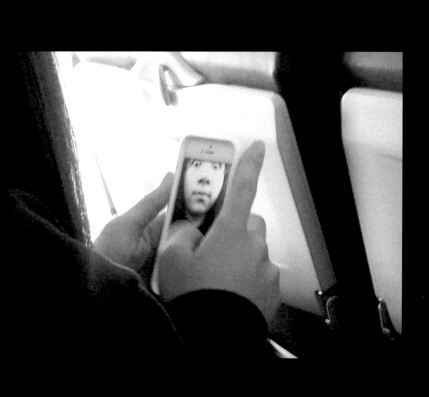

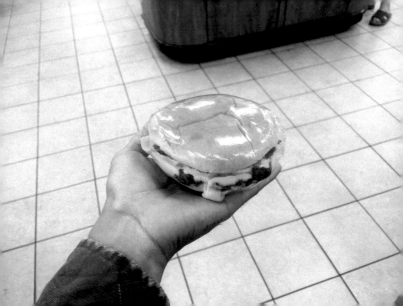

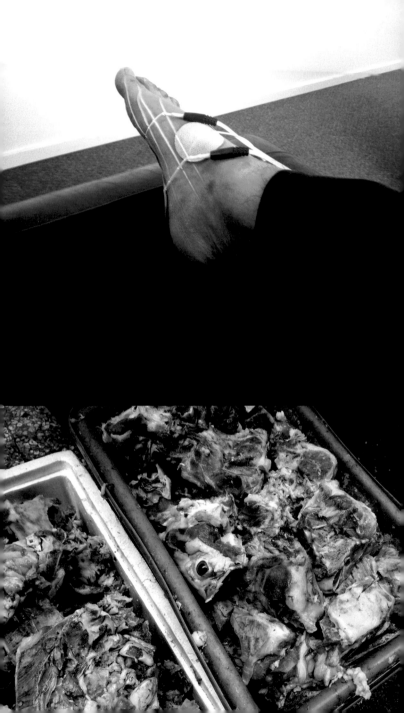

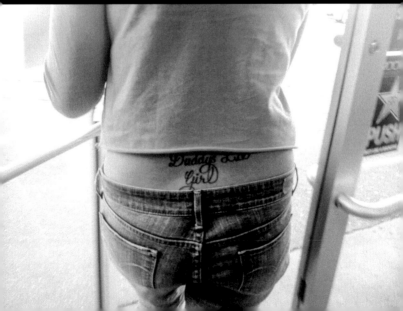

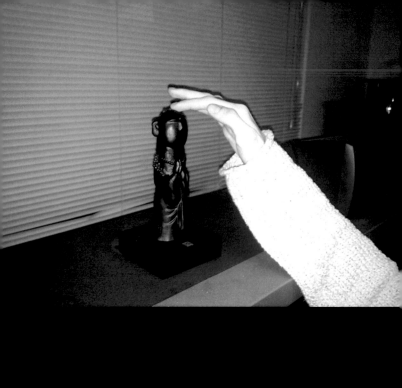

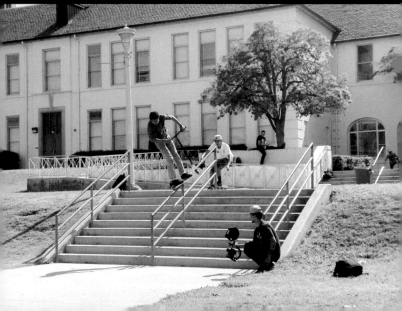

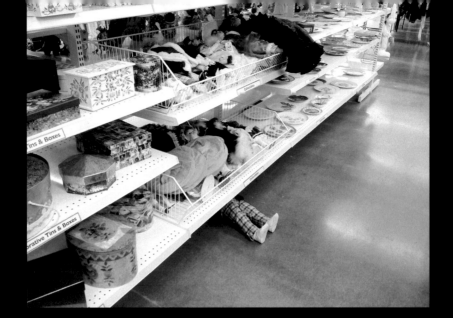

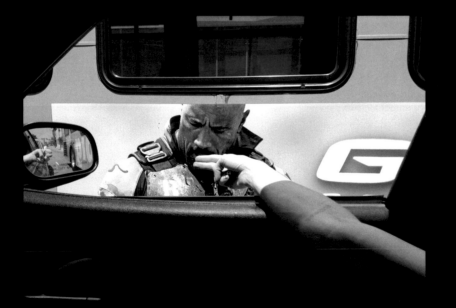

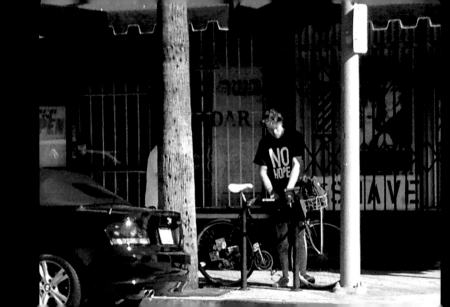

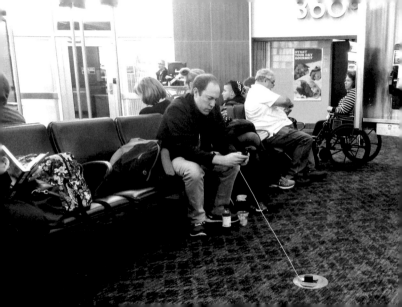

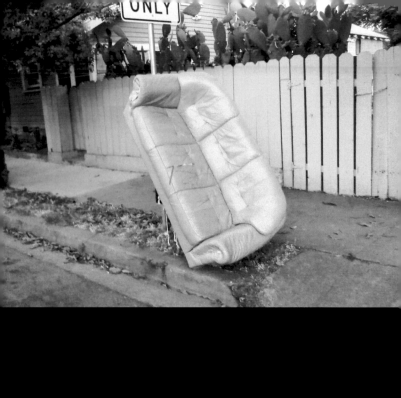
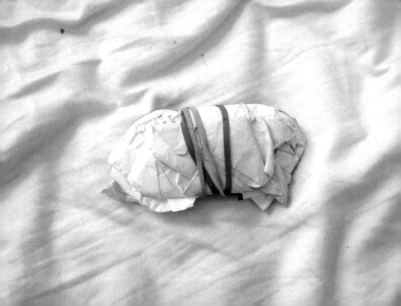

ur longer than Mc- offers its Egg Mc-

can turn the break- versation into a e race," Taco Bell Brian Nic- n an inter- oting that intends to ng number McDonald's in

ld's has long been od leader in the in the U.S., with

sales. But the chain has been facing stiffer competition in recent years, with competi- tors such as Starbucks and Subway rolling out breakfast sandwiches as well.

It's not clea how Taco Bell entry into brea fast will alter t fast-food la scape. Last y an executive w Taco Bell's parent comp Yum Brands said that bre fast accounted for about f

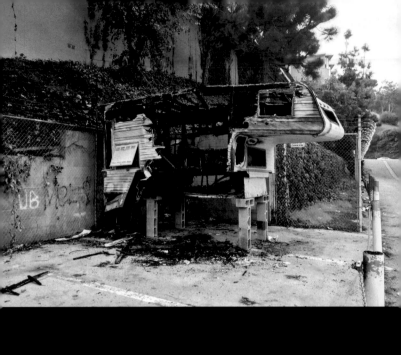
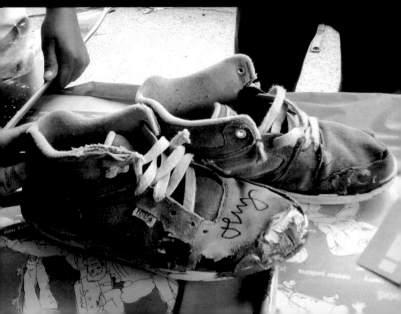

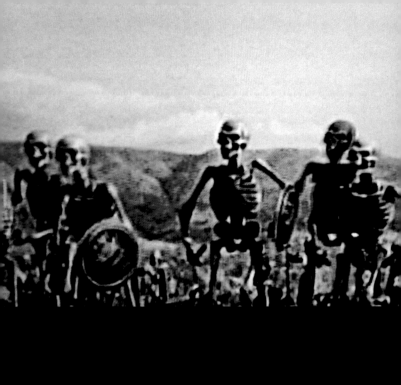

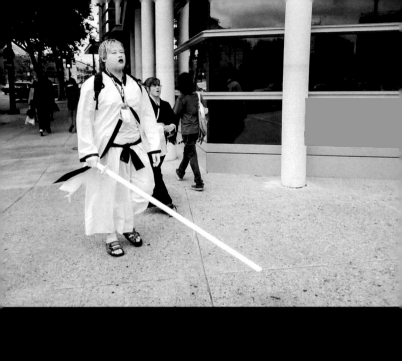
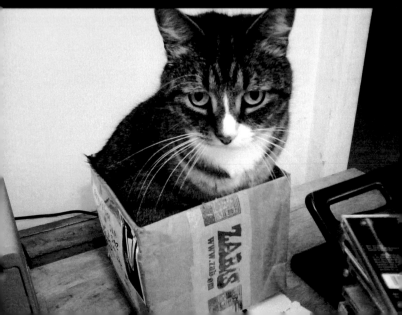

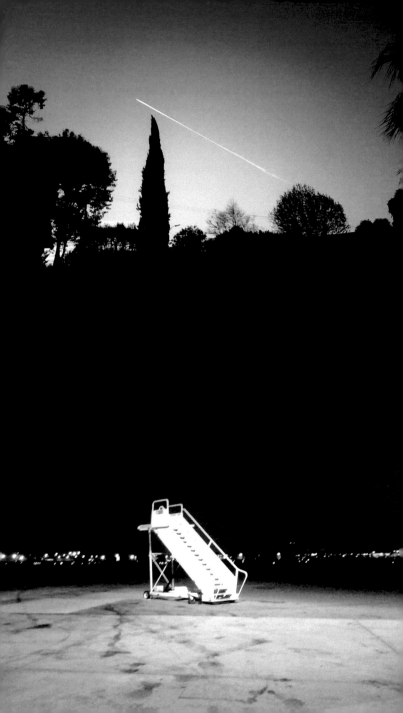

$1.25 AO $1.25 A2

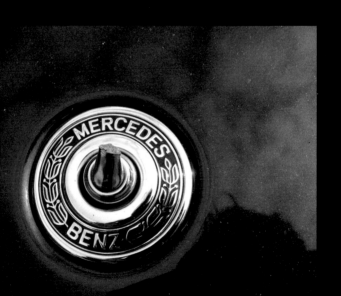

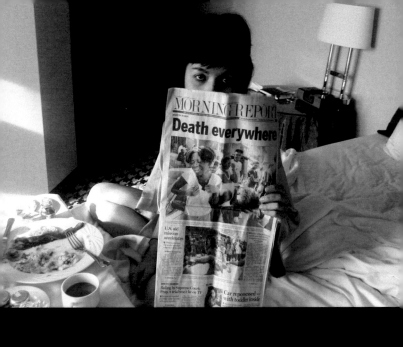

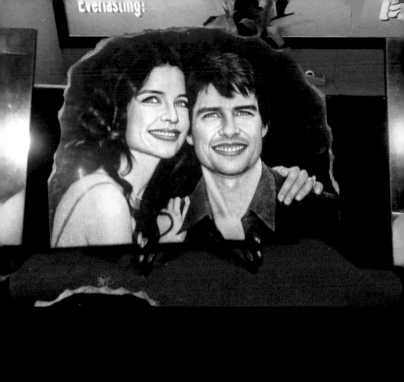

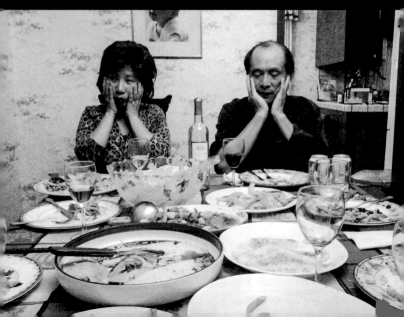

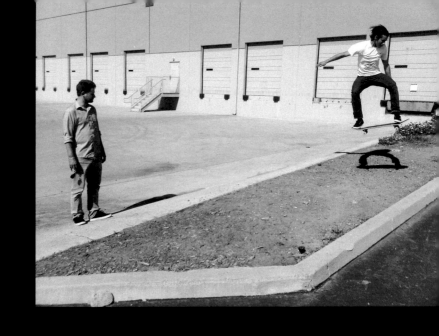

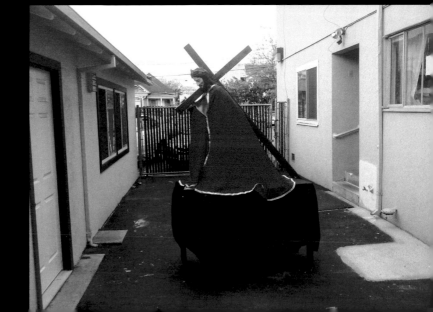

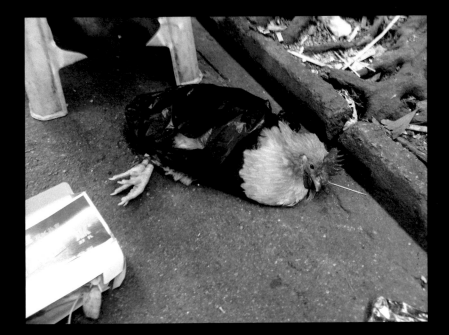

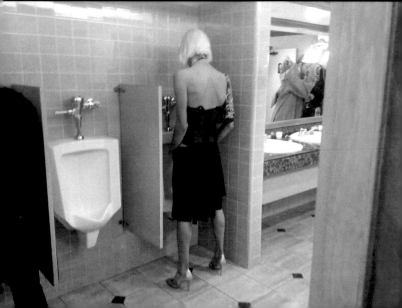

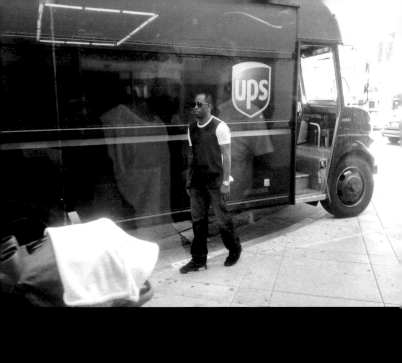

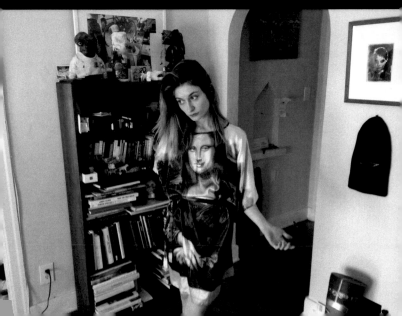

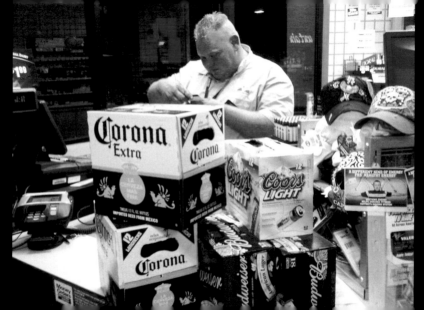

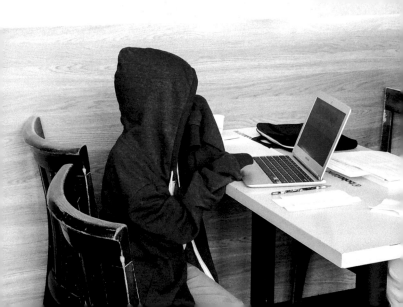

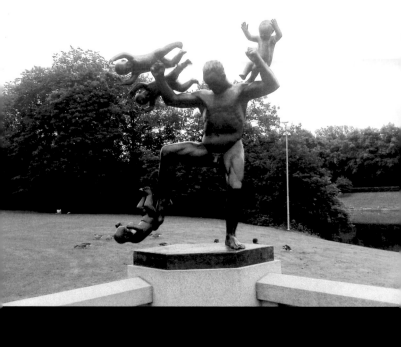

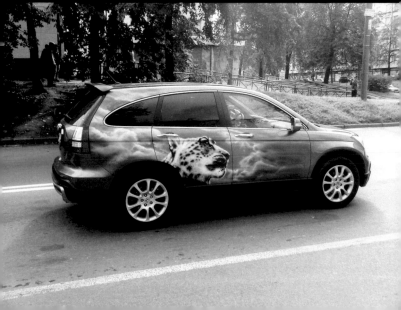

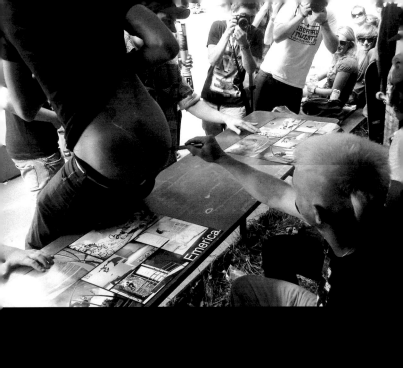

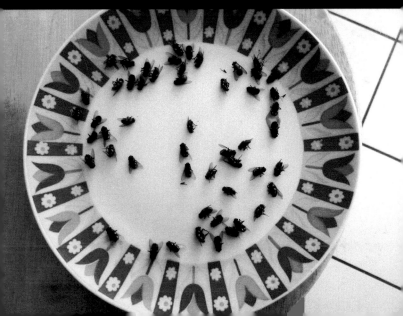

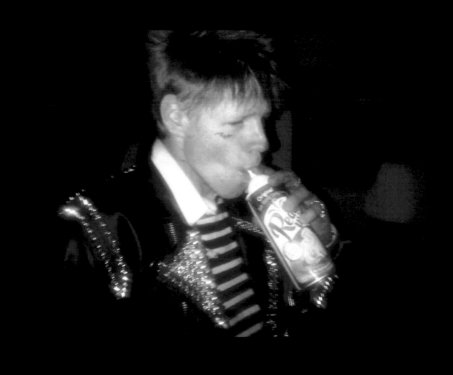
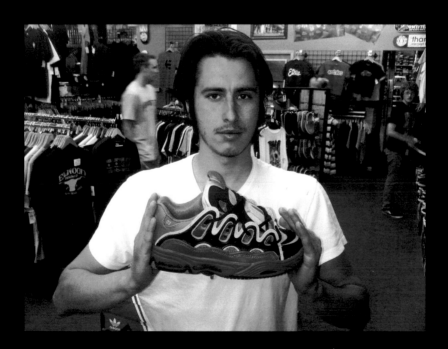

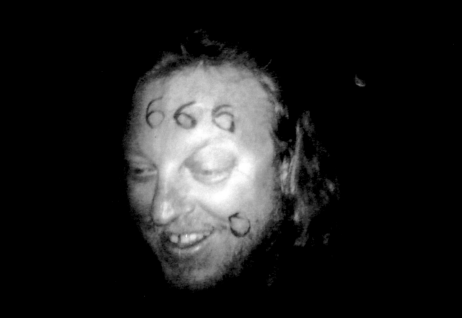

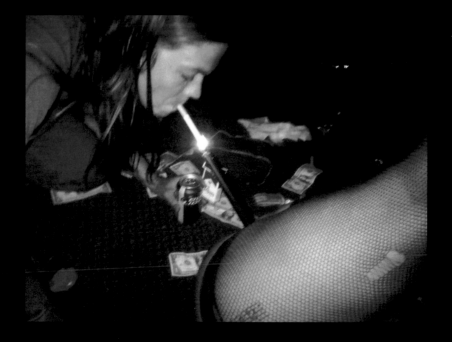

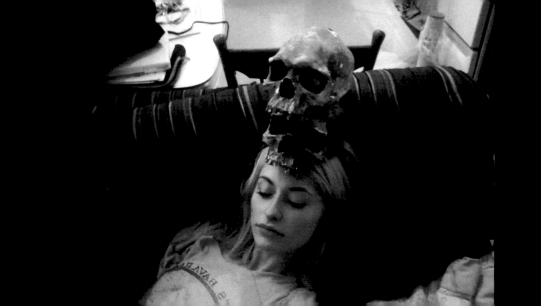

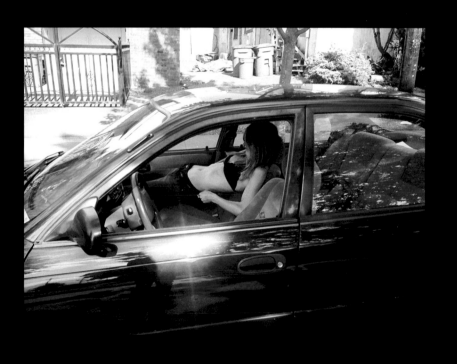

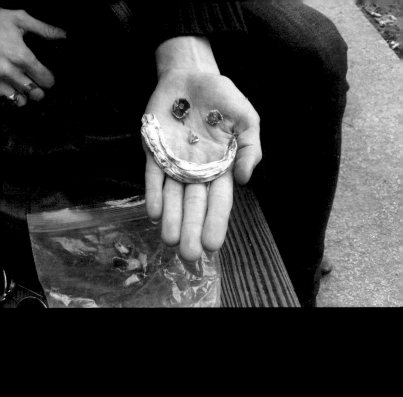
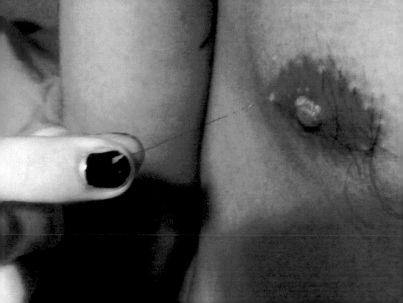

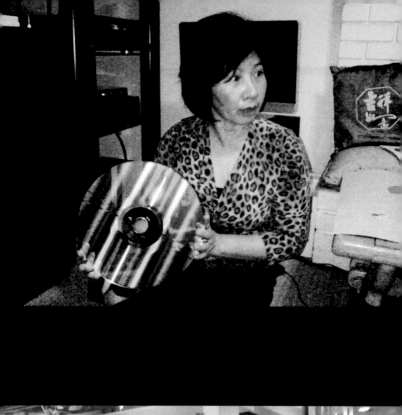
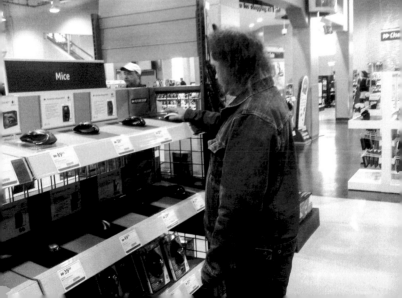

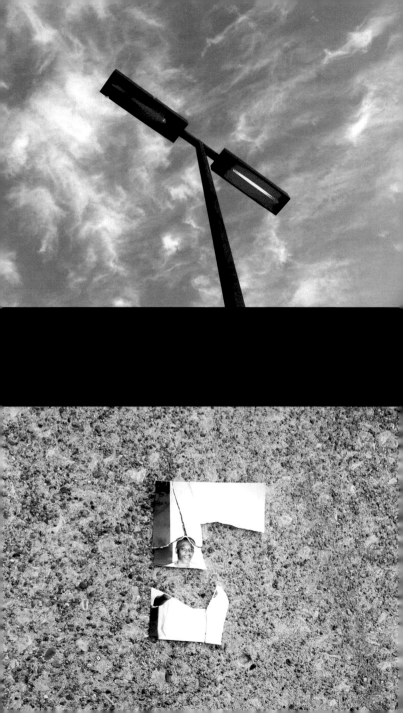

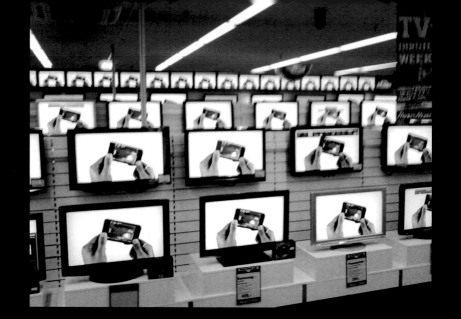

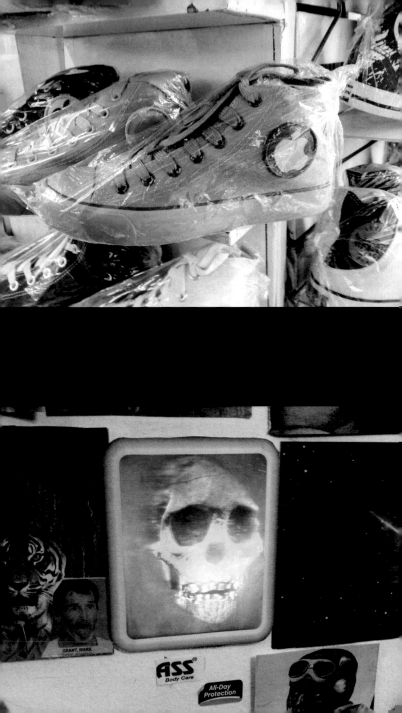

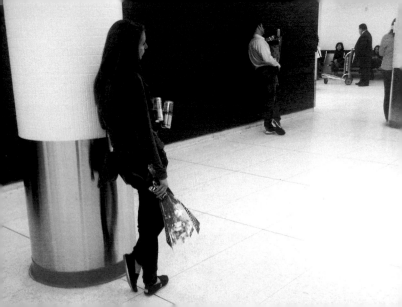

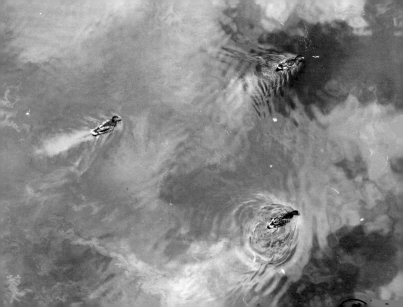

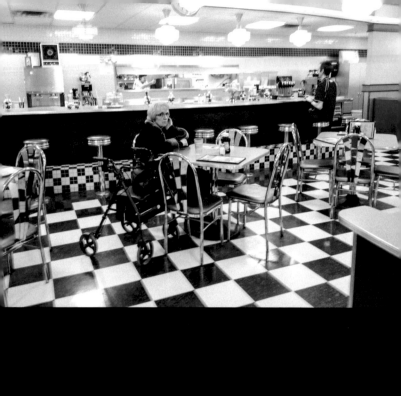
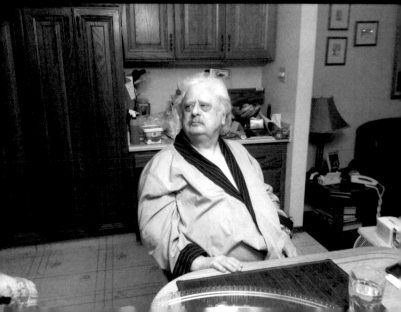

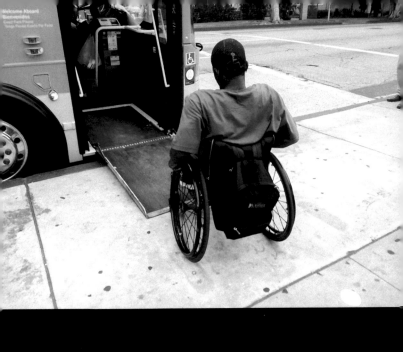

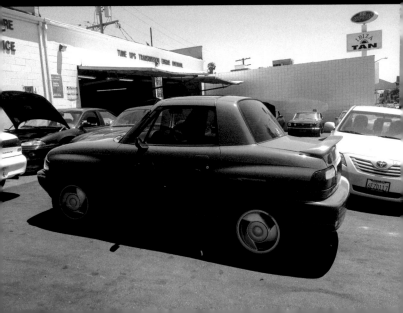

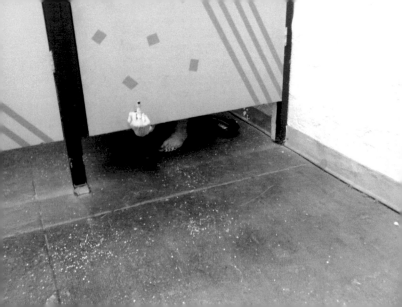

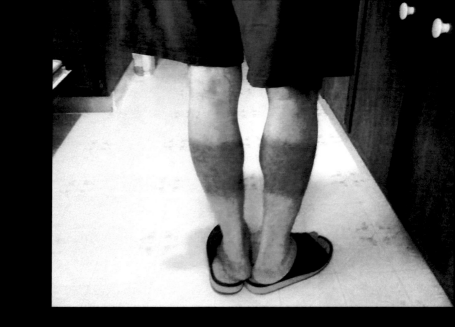

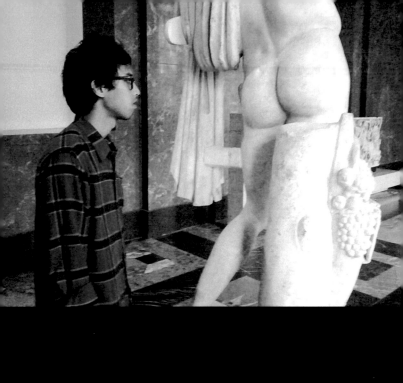
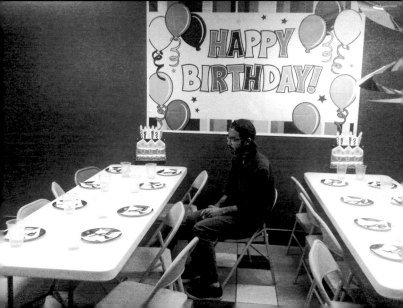

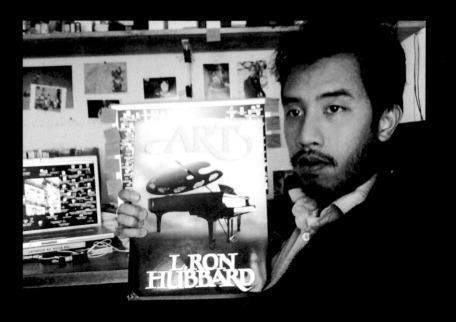

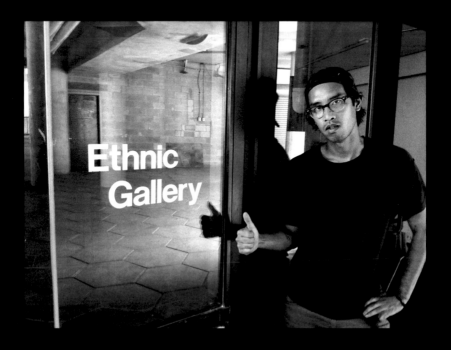

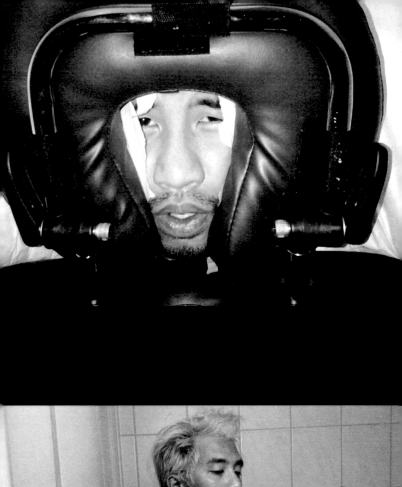
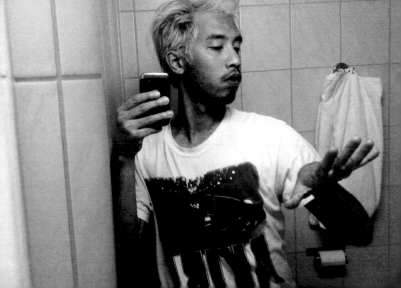

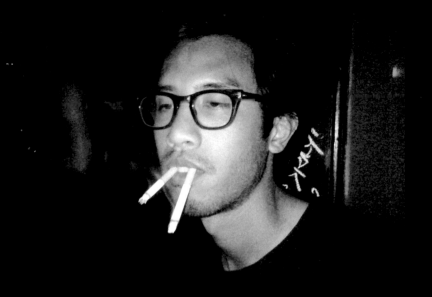
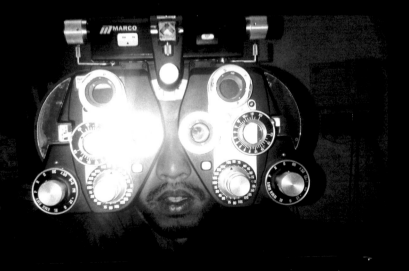

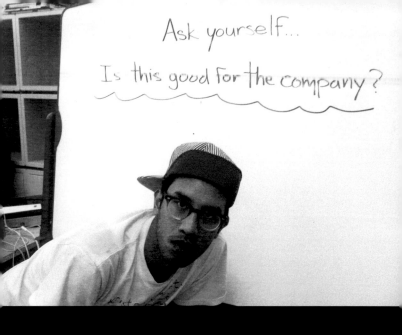

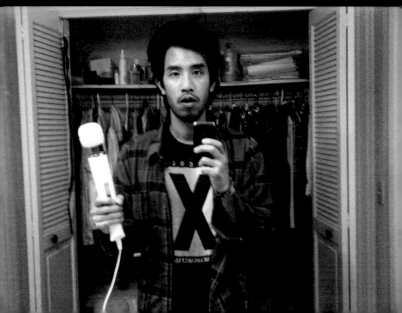

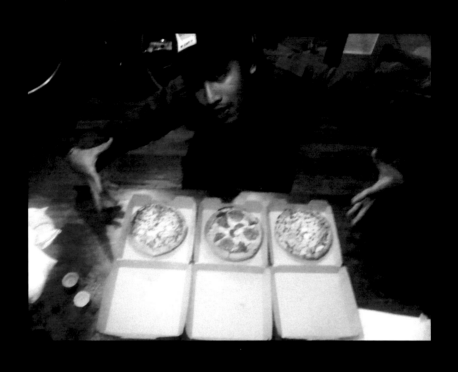

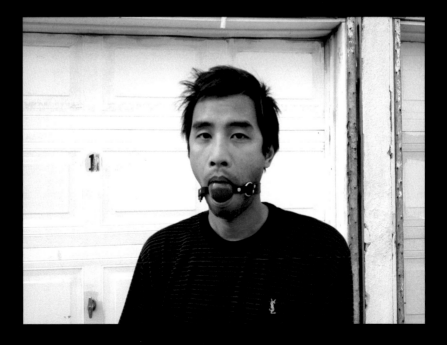

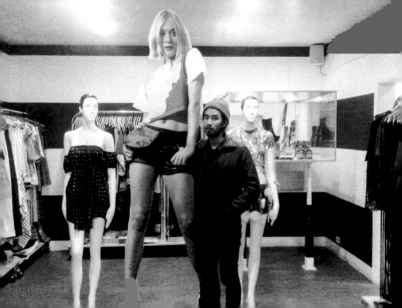

3 TEENAGERS
AT A TIME, PLS

No Homophobia

That so gay!

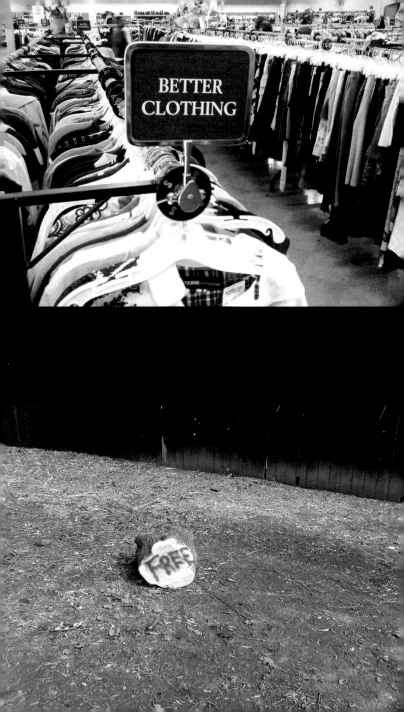

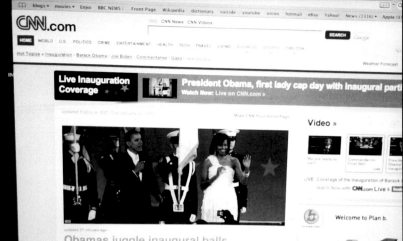

RSS ▾

blogs ▾ movies ▾ Enjoi BBC NEWS Front Page Wikipedia dictionary suicide youtube onion hotmail eBay Yahoo! News (1316) ▾ Apple (1

CNN.com

CNN News CNN Videos

SEARCH Google

HOME WORLD U.S. POLITICS CRIME ENTERTAINMENT HEALTH TECH TRAVEL LIVING BUSINESS SPORTS TIME.COM

Hot Topics » Inauguration · Barack Obama · Joe Biden · Commentaries · Gaza

Weather Forecast

Live Inauguration Coverage ★ ★

President Obama, first lady cap day with inaugural parti
Watch Now: Live on CNN.com »

Updated 8:23 a.m. EST, Tue January 20, 2009

More CNN Your Home Page

Obamas juggle inaugural balls

updated 21 minutes ago

Hours after delivering his inaugural address, Barack Obama and first lady Michelle Obama are spending the evening dancing at inaugural balls. In his speech, Obama promised to tap the virtues and resiliency of Americans as his administration ushers in an era of accountability and improved dialogue with the world. *developing story*

- Explore satellite image | Before and after »
- **Watch coverage on CNN TV, CNN.com Live**
- Obama's inauguration Day » | More videos

- Full address » | Text | Rate Obama's speech
- **The Moment:** Oath in 3D | The inside story »
- iReport.com: Send us images | iReporters share

Video »

We are ready to win!

Commander-in-Chief Ball

LIVE

Pres-in Obama inaugur

LIVE Coverage of the inauguration of Barack

Watch Now with **CNN**.com Live & █████

Welcome to Plan b.

broth
at your sid

PLEASE PUSH THE BUTTON
TO NOTIFY YOUR THERAPIST
THAT YOU HAVE ARRIVED

1 2 3 4 5

6 7 8 A B

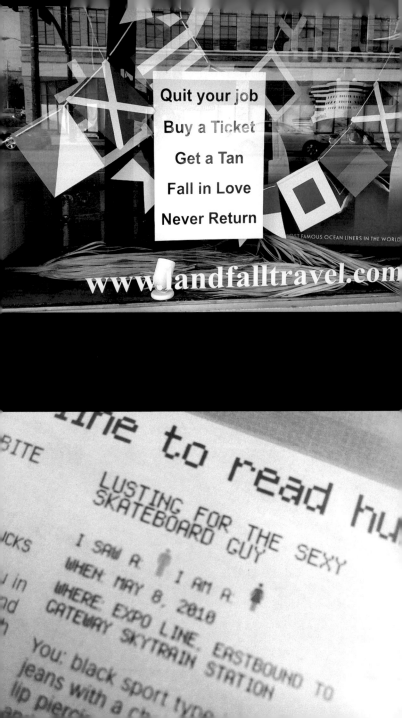

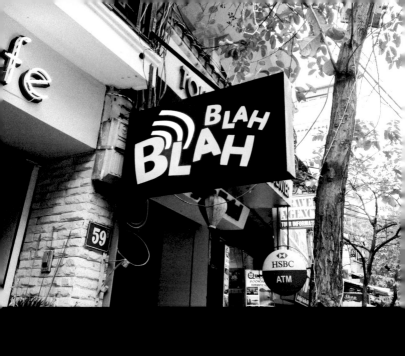

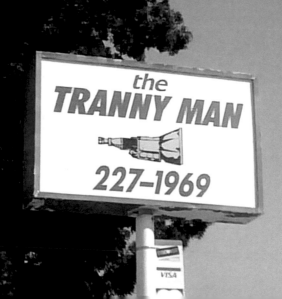

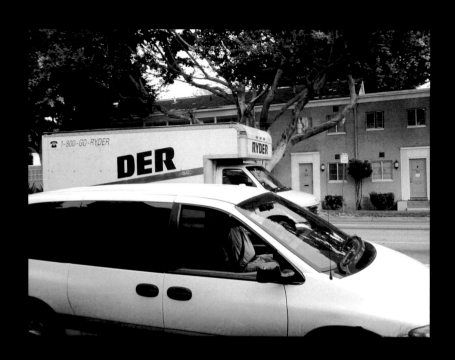

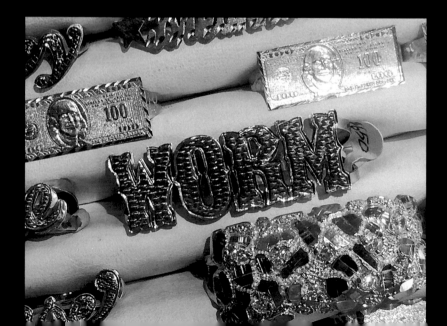

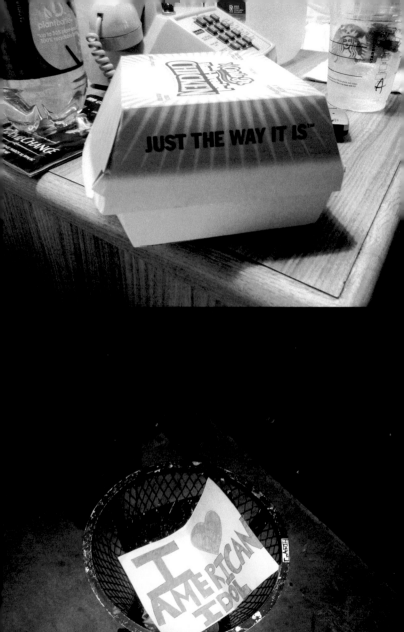

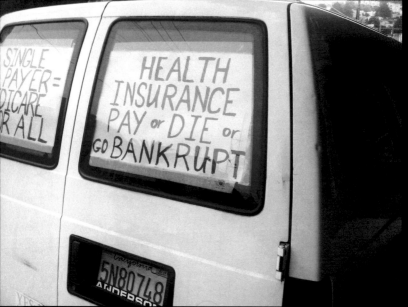

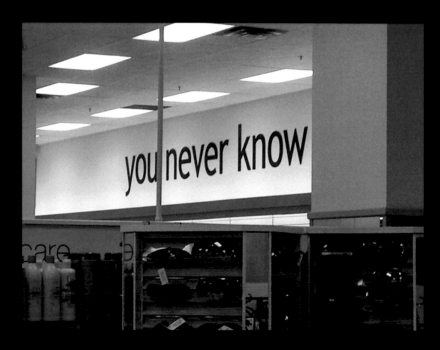

MOST COPS DONT WANT TO
STEAL CARS, THEY'D RATHER
FIGHT CRIME.

872AX29

CHECK MATE,
ABORTION IS MURDER, AND MURDER IS A CRIME

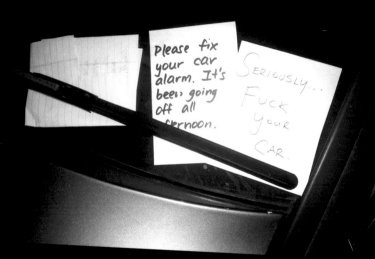

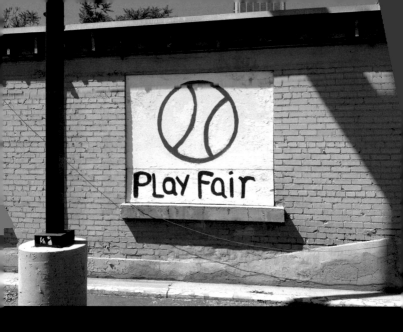

Play Fair

PRESBYTERIAN CHURCH

WHO AM I ?

SUNDAY WORSHIP
10:30 AM (408) 297-7212

VISIT OUR WEBSITE
www.fpcsj.org

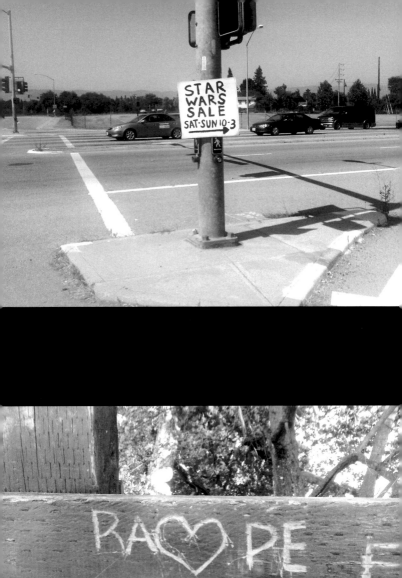

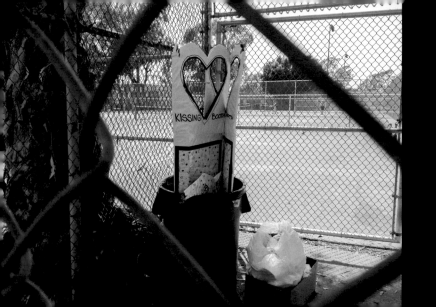

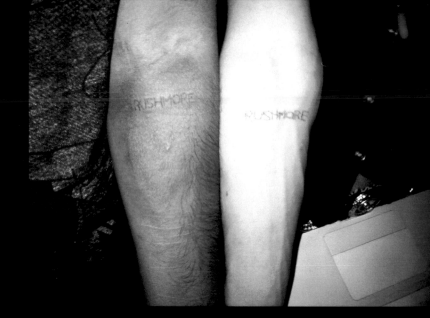

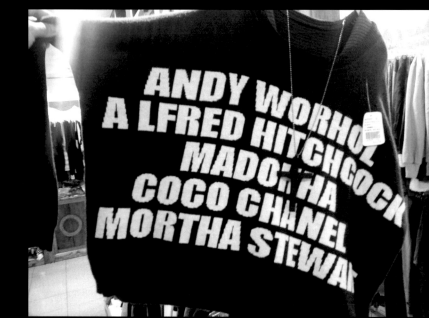

ANDY WORHOL
A LFRED HITCHCOCK
MADONNA
COCO CHANEL
MORTHA STEWAR

Mom defends pic of
baby with bong

Steve M
jam for
4:11

Please Donate
For Kidney
Transplantatio
Of A Poor Guy

Rar

#3

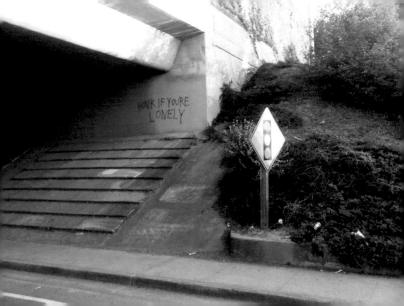

The Beautiful Flower Is the World is a series of photographs that originally appeared on my blog *NAZIGOLD* (2009). They were made using the cameras on BlackBerry Pearl 8100s and then on early iPhones. I was initially attracted to the immediacy and practicality that phone cameras offered, as note-taking devices and essential external memory for myself. Cell phones are critical tools for modern life—we don't have to remember phone numbers, do simple math, or know the way to our homes. For me, the cell phone camera began as a tool, like a calculator or a map. The phone was an apparatus but eventually became another full-time camera.

Sending images through cell phones was not a new thing, but at the time it was expensive, and something I rarely did—that is, until the BlackBerry Messenger (BBM) and iPhone Messenger apps became available. All of a sudden I had the capability to send images cheaply, easily, and quickly, using data, not text. BBM influenced the way I used my phone/camera by enabling me to immediately share a moment with someone else almost anywhere in the world, effortlessly. Today, it's hard to imagine a digital landscape lacking image-sharing and the shorthand language of trading photos taken with a phone. Communicating with people was how this series began.

These photos were never meant to exist in a nondigital space. Ironically, I archived them more efficiently than I did my film photographs—a medium meant for material objects. Saving them was a habit I'm grateful for now, because they would otherwise have disappeared into a digital oblivion: lost in text chains, discarded with phones, or, now, sitting in some rarely visited cloud until someone decides to turn it off. The technological boundaries gave the photos a charm and uniformity I wanted to figure out and explore. This book is a physical manifestation of the same impulses that inspired the blog; to transcend the limitations of a terrible phone camera, and to share the resulting images with others.

THANK YOU:
Katina Danabassis
Jesse Pearson
Now I Remember
Johan Kugelberg
Jesse Pollock
Tim Barber
Tino Razo
Todd Bratrud